Photography

Photography

Thomas Harrop, M.S.

Whitefish Editions
LAKEWOOD, COLORADO

Thomas Harrop, M.S.

Whitefish Editions
Lakewood, Colorado
email: thomharrop@icloud.com

Second Edition published 2013
Copyright © Whitefish Editions 2013

You can see color versions of all images in this book on our website at:
www.lbdphoto.com

Book Design: Diane Hokans Design
dianehokans@icloud.com

All rights reserved under International and Pan-American Copyright Conventions. No part of this book may be reproduced in any form or by any electronic or mechanical means, including information storage and retrieval systems, file sharing or via the internet without permission in writing from the publisher.

ISBN: 978-1-304-29049-6
10 9 8 7 6 5 4 3 2

Printed in the United States of America

Contents

www.lbdphoto.com

Photo Assignments:

1) Freezing Action .. 9
 Assignment 1.1 — Controlling motion 9
 Assignment 1.2 — Moving water 13
 Assignment 1.3 — Shooting inside at night 15

2) People ... 19
 Assignment 2.1 — A first portrait 19
 Assignment 2.2 — Windowlight portrait 21
 Assignment 2.3 — Editorial portrait 23
 Assignment 2.4 — More than one subject 25

3) Nature, Up Close ... 27
 Assignment 3.1 — A single flower 27
 Assignment 3.2 — Patterns of nature 31
 Assignment 3.3 — Arrange a photo with natural items 33

4) Nature on a Grand Scale .. 35
 Assignment 4.1 — The Landscape 35
 Assignment 4.2 — Cityscape 39
 Assignment 4.3 — Night landscape or cityscape 41

5) Architecture ... 43
 Assignment 5.1 — The Interior 43
 Assignment 5.2 — Building Exterior 47
 Assignment 5.3 — Architectural Detail 51

6) Product Photography ... 53
 Assignment 6.1 — Extend a Campaign 53
 Assignment 6.2 — Create an ad 57
 Assignment 6.3 — Product with Person 59

7) Travel ... 61
 Assignment 7.1 — Detail that defines a place 61
 Assignment 7.2 — Fun activity 63
 Assignment 7.3 — Food on location 65

8) Photo Story .. 67
 Assignment 8.1 — Create a photo story 67

A Short Technical Guide:

Making A Great Image Capture..74
What makes an image capture better? 75
 Exposure 75
 Aperture 75
 Shutter Speed 76
 ISO 76
 Sharpness 77
Best Moment...77
Best Lighting...78
 Brightness 78
 Color 79
 Contrast 79
 Specularity 79
 Direction 80
 A word about front lighting 80
Best camera angle..80
Single idea per image...81
Metering..81
 Metering modes 82
 Average 82
 Computer averaged or matrix 82
 Specialty camera modes 83
 Spot metering mode 83
Light..83
 Reflected Light versus Ambient Light 83
 Ambient Light versus Added Light 84
White Balance ..84
 What is RGB and why do we use it? 85
Basic Zone System ...85
ISO-Based Exposure ..87
Camera Stabilization..90
 Tripod 90
 Monopod 91
 Rice bag 91
 Pressing against a stable object 91
 Stable hand holding 92
 Using the IS mode on a lens 92
About Light...93
 Intensity 93
 Color 94
 Source size 94
 Direction 95
Aperture, Shutter Speed and ISO..99
Aperture..99
 The lens opening 100
 The whole f/stops 100
 Selecting f/stops in portraiture 102

Window Light Portrait Setup 104
Shutter Speed .. 104
 Controlling Motion 105
ISO... 106
Composition..107
 Creating Composition 108
 Balance 109
 Geometric Center vs. Visual Center 109
 The Visual Center 109
 Motion vs. Static Balance 109
 Rule of Thirds 111
 Dynamic Symmetries 112
 Gaze motion studies 119
Color ... 119
 RGB – CMY 120
 Color temperature 121
 Photoshop color 122
 Flesh tones 122
What does Photoshop do? ...123
 Parts of the Photoshop desktop 124
 Toolbox 124
 Menus 125
 Palettes 126
 Canvas/image area 126
Using Photoshop ...127
 What are image formats? 127
 What does P.P.I. mean? 128
 Resizing and reformatting images 128
 Color correction 129
 Curves correction 130
 Sharpening 131
 Unsharp masking 131
Digital Asset Management... 133
 Downloading your images 133
 Backup first! 132
 Converting to DNG format 133
 Structuring your file names 134
 Append standard metadata tags 135
 Rate your images 134
Storage and backup ..135
 How many copies? 135
 Setting up your file structure 136
 Directory naming 137
 DVD and CD naming 137
 Tracking derivative files 138
 Logging your shoot in 138

Assignment 1
Freezing Action

Assignment 1.1 – Controlling motion

Photograph something moving, such as a ceiling fan, cars, kids on skateboards or anything else that moves, and keeps moving somewhere you can photograph it for half an hour, or so.

Your camera has several controls that work together to make a correct exposure. One is the ISO, which is the sensitivity of the camera chip. The second is the aperture, which is the opening in your lens through which light passes to record an image. The third control is the shutter speed.

As light enters your camera, the length of time that it is allowed to strike your camera chip must be carefully controlled. This control is the shutter speed. The shutter is like a window curtain that opens and closes and allows light to enter your camera for a specified amount of time. The time is measured in seconds and fractions of seconds.

The shorter the amount of time light is allowed into the camera, the better the camera slows or stops motion of your subject. For example, a shutter speed of 1/1000 of a second will stop most motion in people who are running, skateboarding or even diving into a swimming pool. Longer exposures—1/30th of a second to several seconds—will allow the subject to blur. [This blur is not always bad as we will see later in this assignment.]

Look at your camera manual or just figure out how to adjust the shutter speed settings on your camera. You may have a "time value" or other mode that automatically selects a shutter speed while setting the other controls to make a good exposure. You may also have to use your camera on manual settings, which will be more difficult.

The assignment is to set your camera to shutter speeds ranging from 1 second to the fastest speed your camera will do. (Probably between 1/4000 and 1/8000 of a second.)

Photograph the action you have selected at as many of these speeds as your camera allows:
1 second, 1/2 sec, 1/4 sec, 1/8 sec, 15th sec, 1/30 sec, 1/60th sec, 1/125th sec, 1/250th sec, 1/500 sec, 1/1000 sec and your fastest speed.

After you have made all of the photographs, look at them in order using Adobe Bridge, LightRoom, iPhoto or some other program.

[If you can't remember what speed you used for each one you can check by looking at the metadata attached to each picture. Metadata is information that is embedded in almost every digital photograph. You can access it by selecting "file information" or a similar setting on your software. You should see a list of all the information about shutter speed, aperture, ISO speed and so on in the list.]

[Here's a tip: If you shoot the photos in the sequence listed and sort them by date, they should be in the correct order.]

Once you get the photos lined up you can look at them and determine a couple of things:

1) Which speed makes the motion stop enough to see what is going on in the photo?

2) Which speed stops the action completely?

As the shutter speed gets faster (that is, the shutter is open for less time) the action is frozen better. Keep in mind, though, that the example you have just created does not give you a rule for stopping motion. If you shoot action again it will probably be faster or slower than the first part of this assignment and that will require fine tuning your shutter speed to stop that action. You have to approach each action shot thinking about adjusting your speed until you get it just right

"A great photograph is one that fully expresses what one feels, in the deepest sense, about what is being photographed."

— *Ansel Adams*

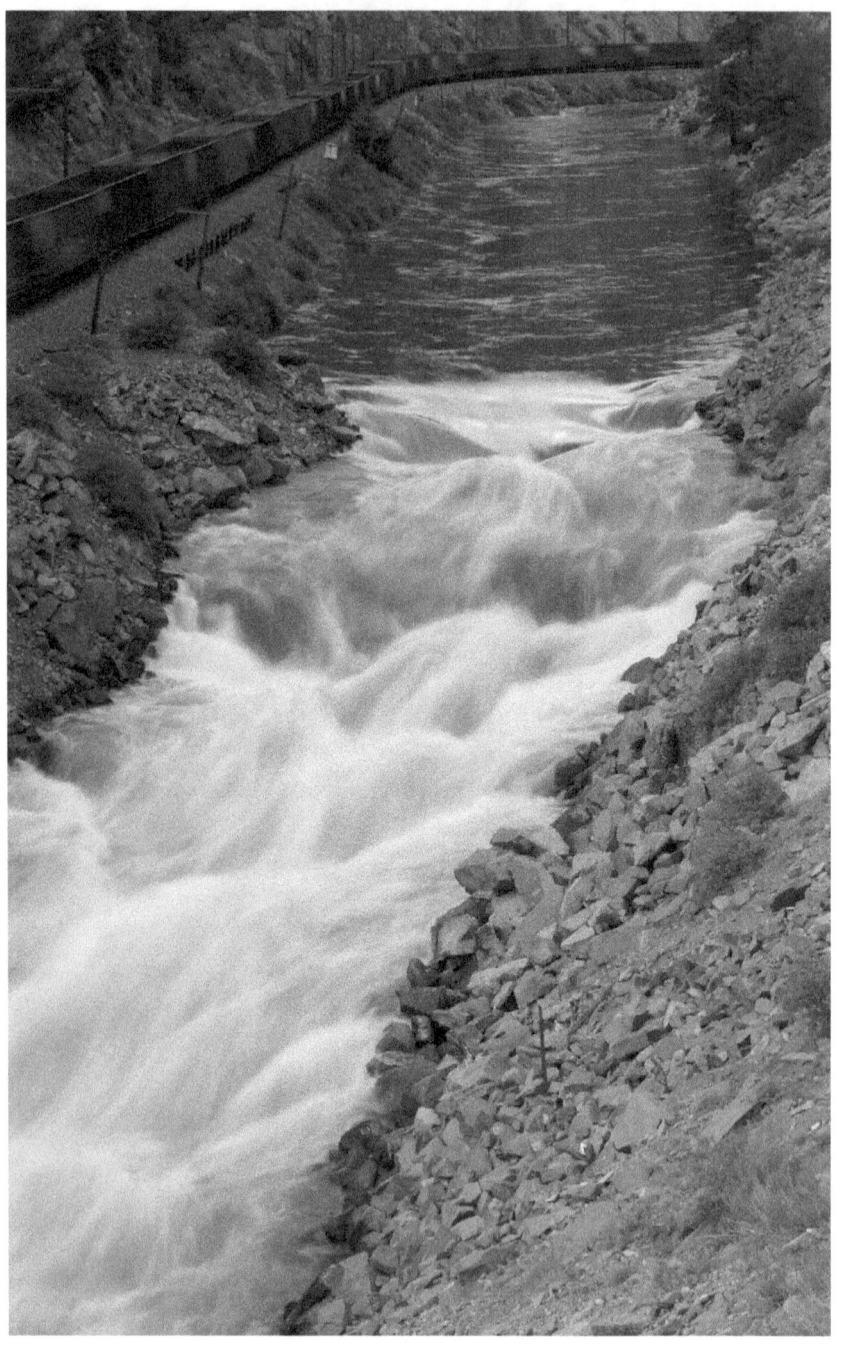

Assignment 1.2 — Moving water

Now that we have an idea about shooting motion, let's try something that landscape photographers deal with all of the time. Water in motion, whether it is a river or stream, waterfall or even waves crashing on a beach, requires the selection of a shutter speed that renders the water in the way that the photographer wants people to see it.

As with any motion, a slower speed will allow the water to blur. With water, though, this is usually desirable. Keep in mind that while we want the water to blur, we want the rest of the scene to be sharp. This means you must use a tripod or some other image stabilizer. If the camera shakes or moves, the shot will be spoiled.

Find some moving water. It can be a lawn sprinkler, the sprayer on your kitchen sink, or even better, a rapidly flowing river or creek. We are going to make a series of exposures of the water and look at them the same way we did with the first shutter speed test.

Because flowing water doesn't move all that quickly, we are going to limit our series of speeds this time. We will do the following exposures, then look at the results side by side again:

1/500th, 1/125th, 1/60th, 1/15th, 1/4th and 1 second

Once you have made the photos look at them again and compare them to see which one you like best for capturing the feeling of flowing water. Also, keep in mind that, like other action, you may find that you need to fine tune the shutter speed based on the speed of the flowing water.

Now decide:

1) Which shutter speed stopped the motion of water completely?

2) Which one do you like most? Why?

Assignment 1.3 — Shooting inside at night

This assignment can be done in your house, a restaurant, or anywhere else you can shoot after dark. The assignment is to make a series of images inside with good sharpness and color.

First, pick a room that you can shoot for at least one half hour. Set your camera on "P" or some other automatic setting and take one photo. This is your comparison so you will know if what you learned in this part of the lesson makes you take better photos.

Next, try shooting the same photo, but with the pop-up flash on your camera if you have one. Now find a piece of tissue and tape or rubber band it over your flash and make the same photo again.

When we are shooting inside at night there is a control that might help and we are going to try it now. If your flash is still popped up, pop it down and make sure it is off. Find the ISO setting on your camera. We are now going to use ISO as a creative control to try to make your photos sharper. Your ISO probably starts at 100 or 200 and may go up as high as 25,000. Because most cameras only have a few, we will try them all. So, shoot the same photo you have been working on but set your ISO to each of the following numbers (if you have them): 100, 200, 400, 800, 1600 and 3200. If you have a higher ISO and want to try it, GO FOR IT!

The final step in this assignment is to set the white balance on your camera. So far we have let your camera set this important function but now we will set it ourselves.

White balance is a setting on your camera that makes colors look better in different kinds of light. For example, "daylight" balance is usually a little sun icon on your white balance menu and can be used outside when the sky is clear and blue. There are several other settings on your white balance menu but we are only going to use two of them right now.

Make one exposure with your camera set to "daylight" and another with the balance set to "tungsten." If you can't figure out which these are, just shoot them all (your camera probably has five or six preset white balance modes. Each setting will make the light a little more red or blue. Later,

we will learn to set a custom white balance to get the best colors in any lighting situation.

Once you have all of your photos shot, spend some time looking at them. Decide which one made the colors look best inside at night.

At the end of this lesson you should know how to stop motion with your camera and how to make the colors look better in different lighting situations. You are well on your way to mastering digital photography!

"To me, photography is discovering rhythms, lines and gradations in reality."

— *Henri Cartier-Bresson*

Assignment 2
People

Assignment 2.1 — A first portrait

Find someone who will spend some time with you working on a series of portraits. It is best if you can get a teen or adult. They are usually more patient and their facial structure makes it easier to see the effects of lighting and other factors on the finished portrait.

Your first portraits will be made outdoors if possible. If not, use a light source such as a lamp whenever we refer to the sun. Make sure your subject blocks the sun. We should not see the sun in the frame at any time.

1) Have your subject face directly toward the sun and take a photo of them.

2) Turn the subject around so their back is to the sun. Make another exposure.

3) Pop up your camera flash, or use a hot shoe flash if you have one, and make another portrait of the subject just as you did in #2.

Now compare the three photos. Which portrait makes the subject's face look best and which one has the best expression?

Assignment 2.2 — Windowlight portrait

For the next series of portraits you will be using light from a window as your main source of illumination. It is best to use a window that faces north. Be sure that rays of sunlight do not fall directly on your subject or the background.

After you have found a space near a large window, seat your subject comfortably with the window about three feet from one side of their face. Again, be sure the direct rays of the sun are not falling on their face, clothing or the background.

Make the following photos:

1) Make a portrait in which the subject's body fills the frame from the top of their head down to about the bottom of their ribs. (This is called a "head and shoulders" portrait.) Use the widest setting on your zoom lens (probably between 15 and 18mm).

2) For the next portrait, move back from the subject and create the same framing but using the longest zoom setting on your camera.

3) Now find something large and white such as poster board or foam-core and use it to reflect light onto the subject [see diagram]. Make another exposure of shot #2 above with the white card adding light to the shadow side of the subject's face.

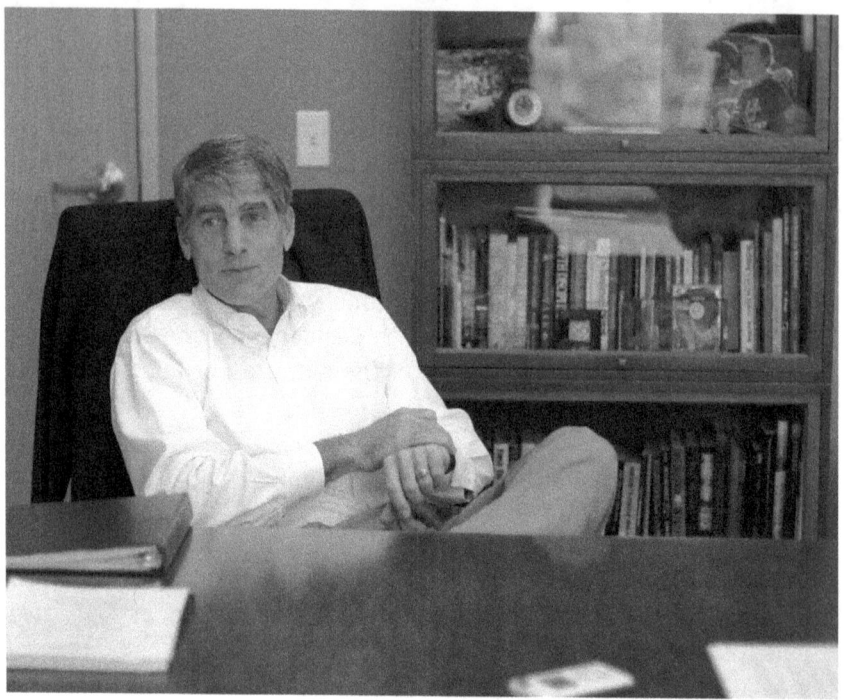

Assignment 2.3 — Editorial portrait

This portrait will show the subject in a setting that gives us an idea of their hobby or job.

You will need to use the widest setting on your camera for this portrait. Include the objects around your subject in the photograph to show something they do for work or play. You may need to rearrange the items in the space to make the portrait work better. For example, you may have to turn their chair around to get more light from a window or you may want to clear up clutter on the desk.

1) All of these portraits will be made using 'available light,' that is, the light that exists in the scene with no flash or other added light. Make a first portrait with the subject sitting and facing the camera. Place the camera at the subject's chest level.

2) Make a second portrait just like step 1 above, but move the camera up to about one foot above the subject's eye level.

3) In the third portrait, have the subject do something such as using a computer, talking on the phone or doing some other task. Once they start doing the task, have them continue to work but look up at you when you tell them to. Most editorial portraits are more interesting if they appear to show the subject engaged in something. This also distracts them a little from the camera and usually creates a more natural image.

[You may not have enough light to make a good portrait and freeze the subject. If that is the case, you can increase the ISO number on your camera. This will make it possible to make a portrait in most lighting situations. ISO numbers usually start at 100 or 200 and go up, doubling each time, until they reach 1600 or 3200. Use an ISO setting that gives you a shutter speed of at least 1/125th of a second for these portraits.]

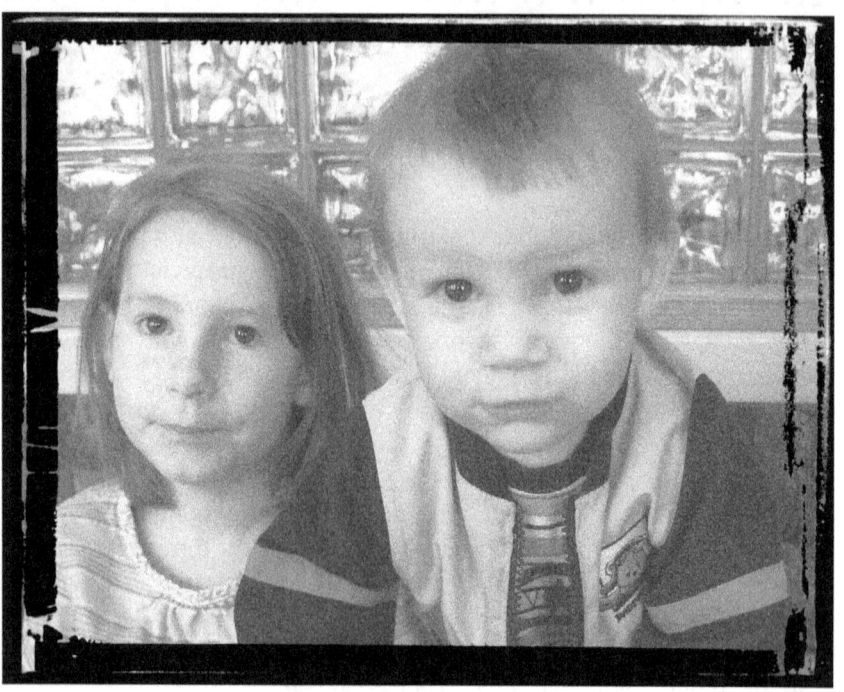

Assignment 2.4 — More than one subject

Using the rule of thirds and the posing methods we discussed, create a portrait with two or more subjects that is well composed and shows all subjects in their best light.

Shoot one image with two or more people using dynamic symmetry, good lighting (window light or outdoor light with flash). Make sure everyone has their eyes open. Everyone should be dressed in similar style. (Don't have one person in a tuxedo and another in cutoffs.)

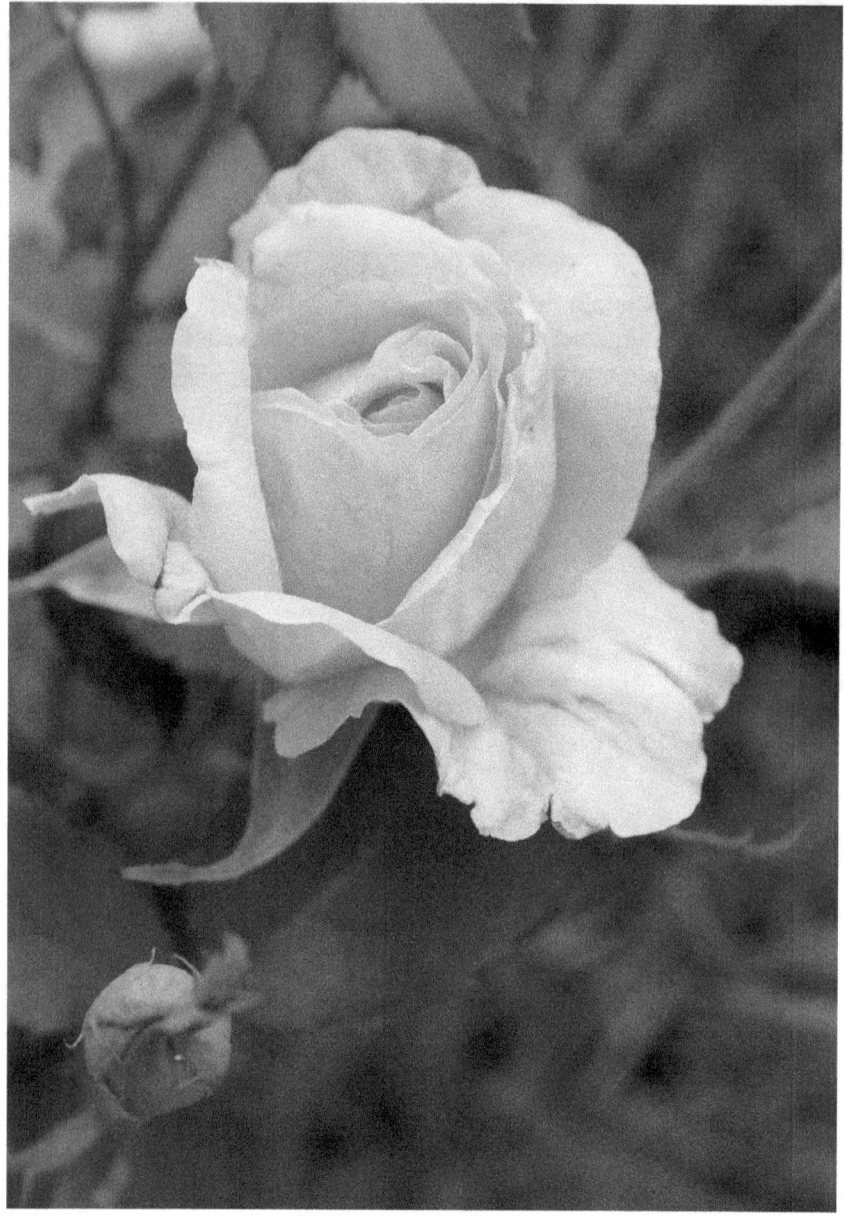

Assignment 3
Nature, up close

Assignment 3.1 – A single flower

Find the most perfect flower you can and make the best photo you can.

If you can get to a botanical garden, you will find thousands of flowers to choose from. If not, look around your neighborhood and in local parks. People on our block have irises, roses, pansies and many other flowers. Be creative. Think about the best place to find beautiful flowers.

1) For your first shot, make the best photo possible with the sun on the front of the flower. You will want to get close. You may need to read your camera and lens manual, or look online to see what the 'minimum focusing distance' is for the lens you are using. Make sure you have a fast enough shutter speed to freeze the motion of the flower. Many times flowers blow in the wind and you may need a speed of 1/250th to completely stop the petals.

2) Next make a photo with the sun shining through the flower. This is called 'transillumination.' It is a great technique to remember. You can shoot many subjects from flowers, to stained glass to fabric with light shining through. It makes the colors brighter and gives the object a warm glow.

3) Now reshoot the transilluminated flower from #2 you just did before, but pop up your flash (or use your hot shoe flash). Sometimes flash balances nicely with the sun coming through the flower. Sometimes it just washes everything out. Read the manual for your camera and flash and see if you can figure out how to make the flash fire at 1 or 2 stops less than the sunlight. This will probably help make the flash less obvious. Remember this trick when you are shooting

people outdoors—a flash held off camera (using a special cable) can be used to great effect if you can control its brightness.

Compare the three photos and decide which one you like best. Did the flash help or hurt the photo? Do you like the image best with the light shining on the flower, or shining through it?

"The artist is the confidant of nature, flowers carry on dialogues with him through the graceful bending of their stems and the harmoniously tinted nuances of their blossoms. Every flower has a cordial word which nature directs toward him."

— *August Rodin*

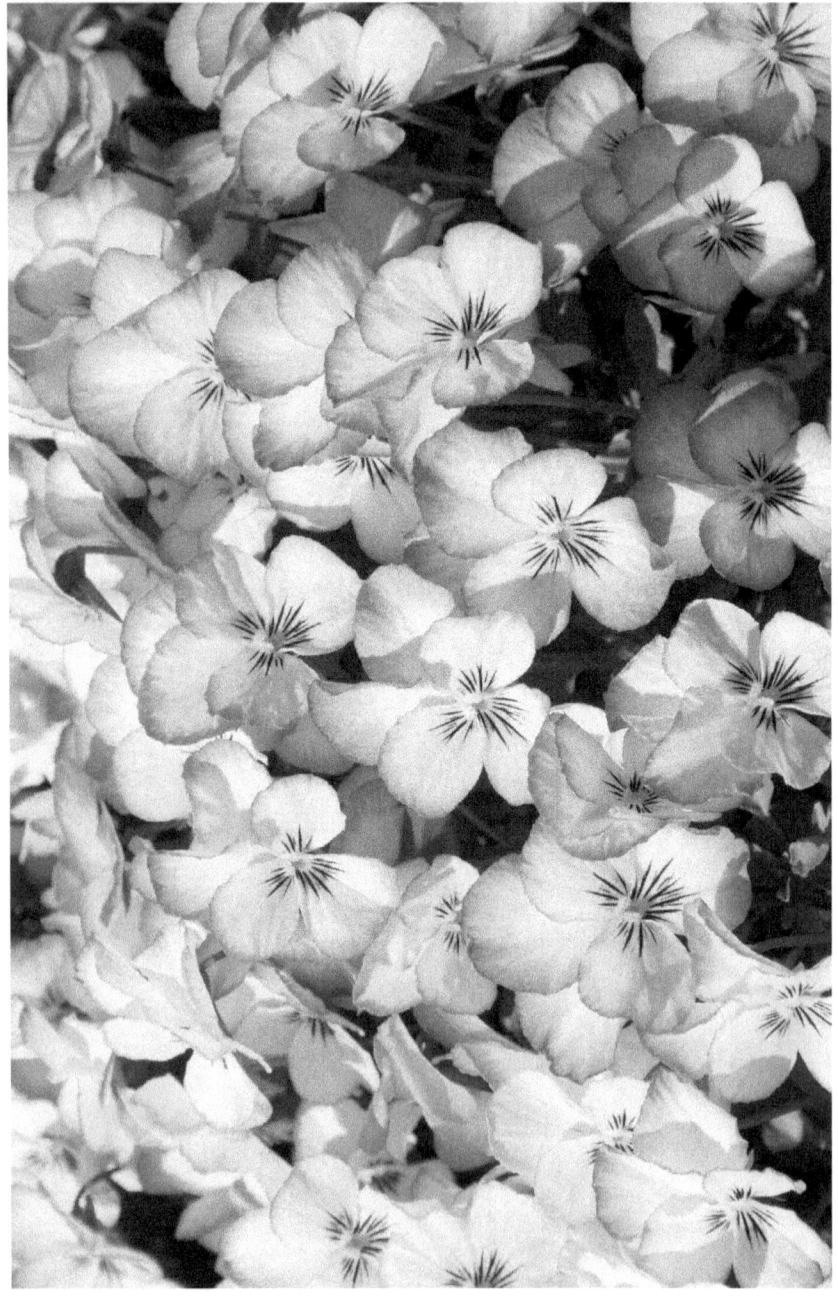

Assignment 3.2 — Patterns of nature

This series of photos will simply be three images that show pattern and repetition in nature.

Make three images that show patterns in nature, such as the texture of grass, the repetition of flowers in a flower bed, leaves on a tree and so on. Each of the three photos should have a center of interest. Perhaps it is a leaf that seems special to you. It might be a flower that is a different color or a unique type of flower.

Use all the techniques we have learned so far. You might want to get very close to see the pattern. Try shooting with the light streaming from behind or falling directly on the subject. Remember your flash.

Use the rule of thirds when placing the center of interest. Place it at one of the strong composition points. Perhaps you can create one of the dynamic symmetries shown on page 112.

Most of all, make photos that share the beauty of nature with people to whom you show the photos.

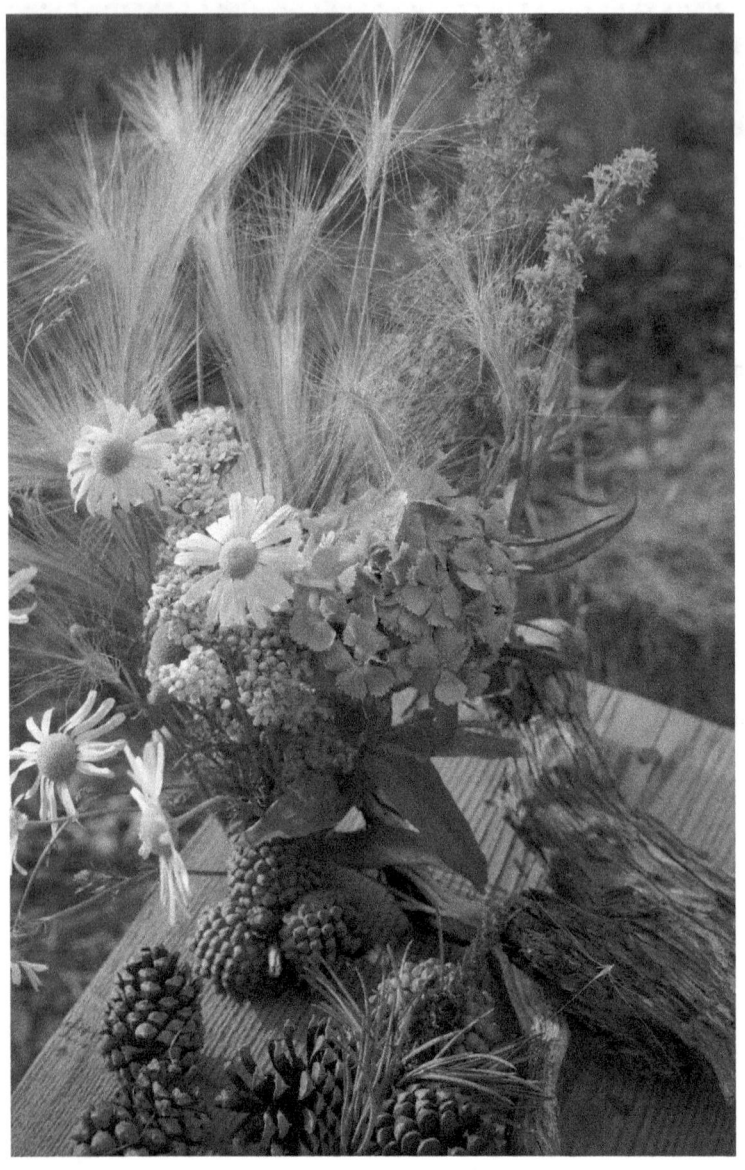

Assignment 3.3 — Arrange a photo with natural items

Find some flowers, bark chips, dirt, sand, seeds or anything else you can think of and create a small still life—in other words, a little setting that is artistically composed. Make it a completely natural scene if you like, or you can make it a small advertising photo. For example you might place hiking boots, a Swiss Army Knife or other prop in the frame to create a center of interest.

Make three images by rearranging the elements in your still life. Work the shot by trying to imagine other camera angles, distances, lighting ideas (For example you could have a friend hold a fallen tree branch with leaves to cast a leafy shadow over the set.) and different placements of your center of interest.

View the three photos in the order they were made and write a brief explanation about why you made the changes you made. Then say which one you like best and why you like it.

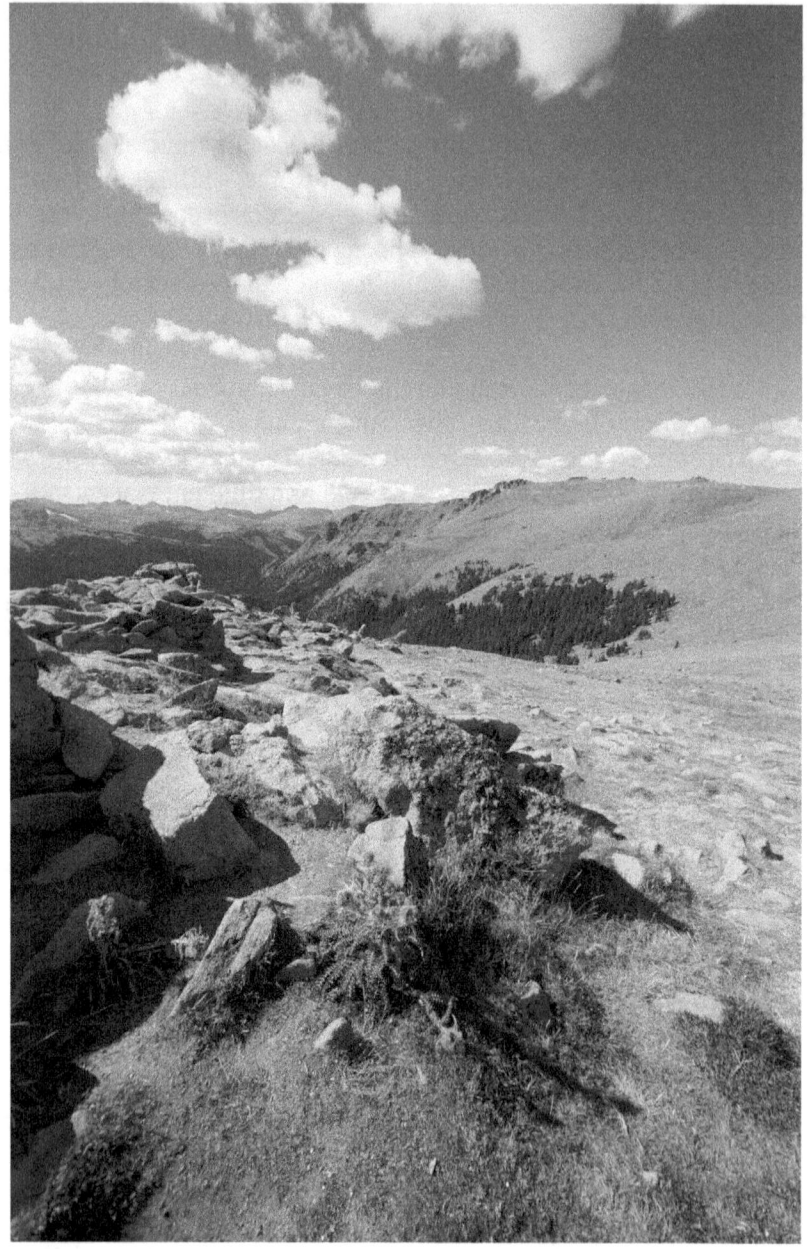

Assignment 4
Nature on a Grand Scale

Assignment 4.1 – The Landscape

If you can get to Rocky Mountain National Park, Garden of the Gods or somewhere spectacular then by all means do it. If you can't, find a park, golf course, open space or hiking trail and show us what you can do with the landscape.

This is another shot you are going to need to work on. First, you need to find a landscape that looks nice. No trash, signs or other distractions. Second, you need to figure out the best camera angle and point of view. Should you shoot it from high up, low to the ground, from an overpass or from the top of your car? It's up to you. Next, you must decide on a lens. A long lens will tend to compress the subject into two dimensions. A wider lens will make the landscape feel more expansive and will accentuate the sky or the ground. You will make three photos for this part of the assignment.

1) When you find the landscape you want to shoot, make one quick image without thinking too much about setting up the shot. Just get an overall shot of the scene for reference.

2) Look at the shot you made for #1 on the back of your camera. Your first decision is whether to make this a shot that is mostly sky or mostly ground. Where are the most interesting details? If your camera has the ability to show a 'rule of thirds' grid in the viewfinder, turn that on now. Set the horizon of the landscape to be on the top or bottom third line and make sure the image is level (the horizon is straight). Now make another image.

3) Time to make the final refinement. Look for any detail in the image that will work as a center of interest. It could be a peak, a cloud, a

building, an old rusted car, an animal or anything else that will give the eye somewhere to rest as it explores your photo. Once you have determined what this thing is, place it on or near one of the strong composition points (Those are the points where the tic-tac-toe board lines cross in your viewfinder.) and make an exposure.

When you have completed all three images, bring them back to a computer and open them all on the screen. Look at them closely and decide which one you like best. It may not be the last one. One of the things I have found over the years is that, many times, my mind resolves an image at the subconscious level better than my higher brain. I call this 'deep composition.' That just means that the brain has created a pleasing composition at a low level in your brain before you had a chance to think about it and screw it up.

"Landscape photography is the supreme test of the photographer—and often the supreme disappointment."

— *Ansel Adams*

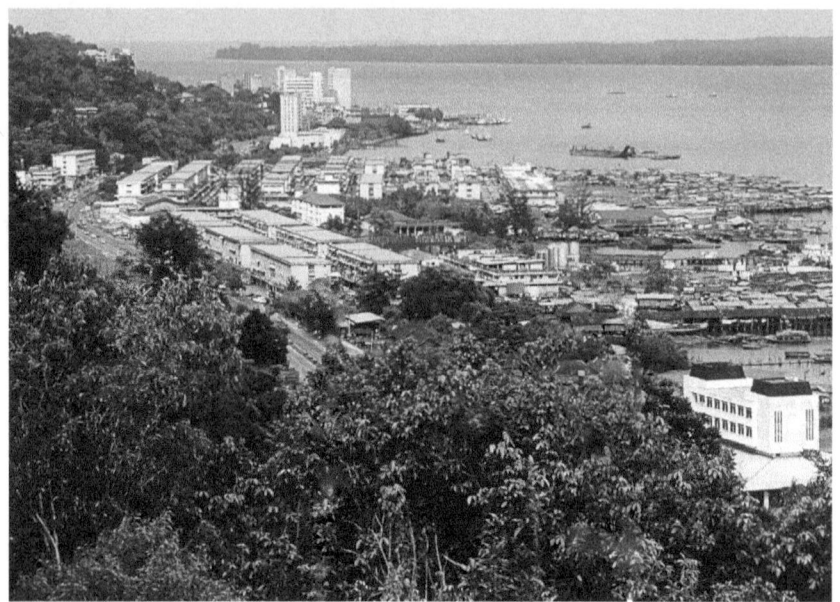

Assignment 4.2 — Cityscape

Whether you live in New York, Denver or San Francisco, your city is defined by its skyline. Find a place to shoot yours and make it look great.

Wherever you live, you will find photographers who will have an opinion about the best vantage point from which to capture the skyline. Try their ideas and a few of your own.

For this part of the assignment, you must scout the city you are going to photograph. I once had an assignment to photograph the town of Eagle, Colorado. I arranged to get up on the roof of a building through a small hatch. I hauled all my gear up there and made several images. They were all terrible for various reasons. Look around the city or town you have chosen and make a few images from different locations. Again, don't think too much about refining the images. Just shoot some photos that let you see the angles.

Take the photos that you made and display them on a computer screen. Look at them closely. What details do you see? Will this shot look better during the day, at dusk or around dark with the lights on. It depends on what you want to say about the city with this photo. Daylight tends to show the colors and the sky (make sure your light source is shining on the front of the buildings you are photographing); sunset shots tend to feature the sky more than the town; evening shots with the lights on seem warm and inviting.

The final product for this shoot will be a series of snapshots showing at least three angles of the city and one final shot that shows the one you decided worked best for this image.

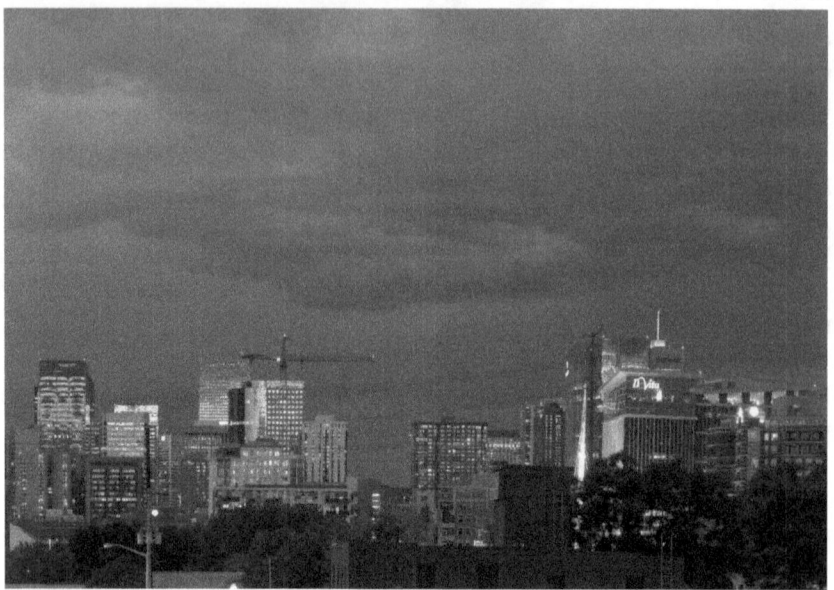

Assignment 4.3 — Night landscape or cityscape

If you can shoot this assignment during a full moon you will get better detail. If not, do what you can and we will work with it in Photoshop. There are two options for this part of the assignment. You can either shoot a landscape outside after dark, or shoot a cityscape after dark. Whichever you choose, you will probably need to set your ISO to a high number such as 1600 or even 3200. Alternatively, if you are in a very dark place, you could shoot the landscape with a lot of sky in the frame and use a very long shutter speed (1 minute to several hours). This technique is called a 'star trails' image in the photo business.

This part of the assignment requires only one final image. Whichever subject you choose, try to use exposure and composition to give us the feeling of what it was like to be there in the dark. We don't have to see a lot of details—just enough to let us know we are not looking at a blank frame.

Another variation you might try is the use of High Dynamic Range imaging, or HDR. Many cameras today have a version of HDR built in. The idea of the technique is simple. You make several exposures (usually three but sometimes more) and merge them together to form a final image that has a longer tonal range than you can get in a single digital photograph. If your camera can do HDR on its own set the range to about three stops above the main exposure and three stops below. If you are going to do this in Photoshop (I do it in Adobe Bridge) then shoot three images with one set to an average exposure, and two other shots that are three stops above and below the first image. If all of this sounds like Latin to you, don't worry about it. Just make the images you can using a single exposure.

If the photos from this shot don't come out exactly the way you like them, don't feel too badly. This is a very difficult photo for a photographer who is just starting to learn the craft. Most of all, enjoy the shoot because these images can be a lot of fun to take and to share.

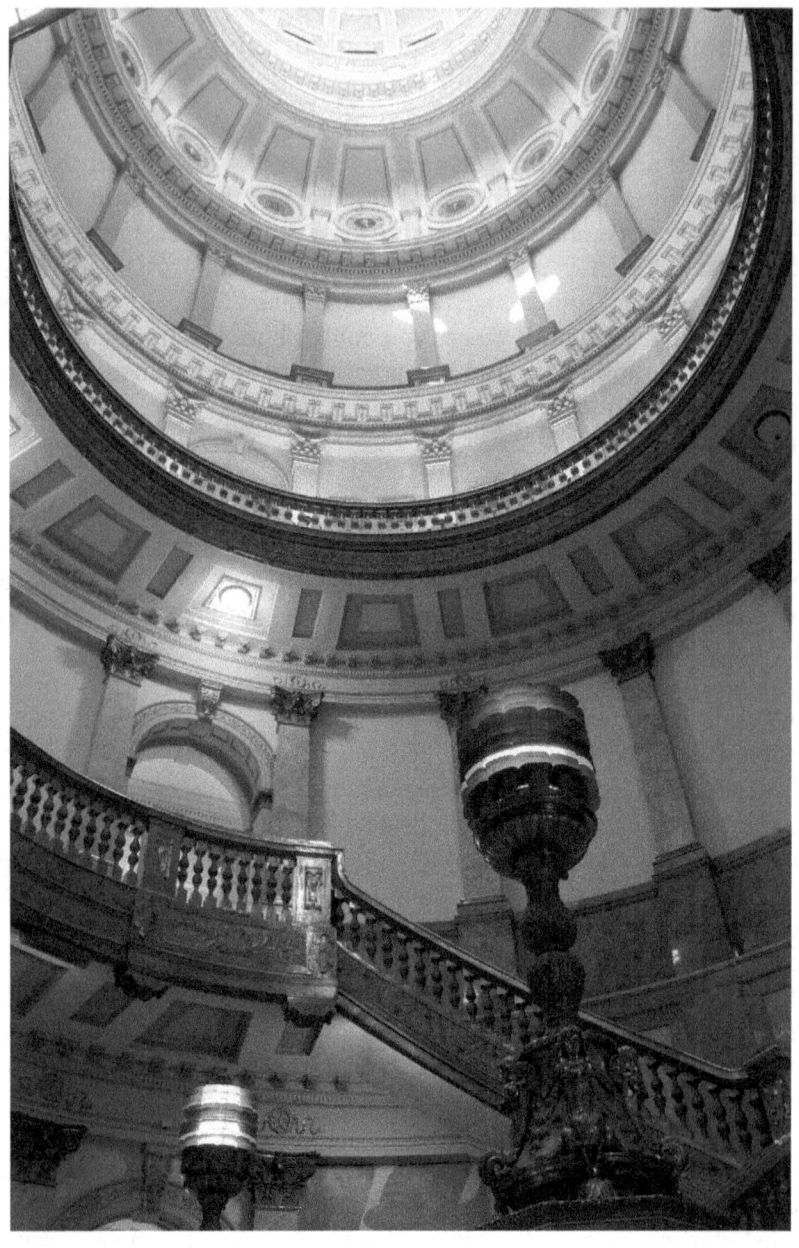

Assignment 5
Architecture

Assignment 5.1 — The Interior

Learning to shoot rooms is a great skill and can be a lot of fun. When you are starting out you probably won't have an extremely wide-angle lens (less than 18mm) so you will have to select a room that works with the equipment you have.

Your first job here is to find a room that you find interesting in some way. Please don't post your photo telling us that your family room is really interesting because it has your game machine and basically, you never leave it. Think about hotels, old barns or other buildings. There are a lot of interesting structures if you spend a little time looking.

1) Once you have found your room, make images of the room from every angle you can find that gives you an overall view of the space. If you can't find at least two or three vantage points you might have selected a room that is too small for the assignment. Try again.

2) Study your photos from #1 on the computer screen. Is the room well-organized and tidy? If not, you may want to do some straightening or even move some furniture, although you should probably ask before you start dragging the sofas around. Decide which angle works best and figure out what you need to do to refine the image. Perhaps you could put a fanned stack of magazines on a table, move a lamp to illuminate a "dead corner" (A corner where there is not enough light to keep it from being black in the photo) or have some people sit in it to make the room feel more alive. The room is your palette, make a painting. Take notes or just remember what you want to do.

3) Now it's time to head back to the room and finish the assignment. With your notes in hand you will probably need to plan on spending

an hour or more working on the setup—cleaning and arranging and getting things just the way you want them.

If you can see through any windows to the sky, the ground or nearby buildings, you may have a problem. While the light you are standing in within the room may seem bright, it will likely be about 1,000 times brighter outside. Here is how you can fix that. Place your camera on a tripod. If you know how to do HDR, just set your camera for HDR with about three stops between frames and shoot images. A better way to do it is to put your camera on manual and shoot photos (without jarring your camera) until you get one with good detail in the world outside. Now shoot one that shows good detail overall in the room. Make a third exposure that provides good detail in the darkest shadows of the room.

Combine three images with the best overall detail, shadow detail and detail in the outside in HDR and, 'Bob's your uncle', you have a perfect shot of the room.

"Architecture should speak of its time and place, but yearn for timelessness."

— *Frank Gehry*

Assignment 5.2 — Building Exterior

Compared with Part 1 from this section, the exterior should be a piece of pie ... no, cake. Yeah, a piece of cake. The biggest problem again will be finding a building that leaves you gasping for breath because of its sheer beauty and lovely setting. If you can't find a building like that, shoot something that you think is nice.

Once you have found your building you need to establish which direction it faces. This is important because it will determine what time of day to make your photos. If your building faces East, you should shoot it in the morning because the sun will be shining on the side you are shooting. With a West-facing building, you should shoot in the afternoon. I hope you can figure out why. Whatever you decide, you should never photograph architecture around noon.

[Tip: A friend of mine (who is one of the top architectural photographers in Los Angeles) once told me that his compass was his most important accessory because it helps him determine the orientation of his assigned buildings. Look around your house or ask friends or family—someone must have a compass somewhere. It you have a smart phone you can download a compass application and that's even easier.

You will be making three nearly identical shots of the building. If you need help remembering from where you shot, another handy trick is to carry a piece of chalk and use it to draw circles around your shoes (if you are hand-holding the camera) or your tripod feet (if you have a tripod and the wisdom to use it). This will allow you to make shots that are as similar as possible. You should also make note of how your zoom lens is set (it should be a number from 18 to 200 in millimeters). Set the lens to the same focal length each time.

Make sure your camera is level. Some cameras have a built-in level. If you don't have that, try turning on the grid in your camera's viewfinder and line up one of the horizontal or vertical lines with something you know is straight on the building.

Now make three exposures. You will make them all during the morning or afternoon (depending on which way your building faces) but they

should be made a few hours apart. If you are shooting East-facing then try to shoot within an hour of sunrise, sometime around mid-morning and between noon and one. For a West-facing building, shoot around 1 p.m., about 4 p.m. and within an hour of sundown.

[BTW, if your building faces North or South, you can shoot with either morning or afternoon light.]

Once you have the images captured, you will need to correct the vertical lines in the building using 'lens correction' in Photoshop. You can either have the filter do the correction for you or you can do it manually.

"Form follows function—that has been misunderstood. Form and function should be one, joined in a spiritual union."

— *Frank Lloyd Wright*

Assignment 5.3 — Architectural Detail

The architectural detail is a bit difficult to define. It can be anything from a little planter or some bricks to nearly the whole side of a building. How much you share in your photo is up to you. The detail must be part of the building, not a statue in front of the building or a flower in the planter near the door.

If you want to save time on this assignment, pick a building for assignment #5.2 (building exterior) that has some nice smaller features or a cool pattern in the siding or windows. That way you can shoot at the same time for both.

Shoot at least two details from the building. You have the choice here to make them black-and-white or color. If you want to make them black-and-white you can use the filter in camera raw or the one in Photoshop. I prefer the Adobe Camera Raw black-and-white filter because it has more colors from which to choose your tones. If you don't know how to make a good black-and-white you can simply do the photos in color.

Assignment 6
Product Photography

Assignment 6.1 — Extend a Campaign

Find an advertising campaign you like and try to make a new ad that extends the series. I don't expect you to have all the props and locations and talent to make a perfect version of the ad. Do your best with what you have and concentrate on the idea. If you can create a polished ad presentation ... more power to you!

We will be looking at several aspects of photography in this lesson. These include framing, lighting, selection and handling of the background, contrast and color, and overall color balance.

Framing: Use the rule of thirds to place your product. Once the product is placed, put props around it to complement the main subject. Make sure nothing covers any of the product and make sure each item in the frame supports the idea of the photo. You get to choose everything in the frame—make sure everything we see is the photo and there because you chose to include it.

Lighting: The light you shoot in should be determined by the product. If you are photographing running shoes, the light should be bright and open. If you are shooting a video game console, the light should feel like the setting for a game or the light in someone's game room. Shooting a Marie Callender's pie? Put it in a kitchen window or on the counter. Think about the light you would normally see this product displayed or used in and try to make it look like that.

Background: The background is critical in advertising photos. Make sure the background is neat and the colors harmonize with the product. If you can figure out how to do it, it is often nice to let the background go

out of focus a little bit. If you want it out of focus but can't shoot it that way, you can always correct it in Photoshop.

Contrast and color: The product should be the brightest thing in the frame or the darkest. The eye seeks out contrast so make sure the whole frame isn't the same tone. You can create contrast by selecting elements that are lighter or darker than your product, or by using size, shape or texture to create a visual difference. It's the same with color. Don't photograph a banana and surround it with yellow props. Use contrasting or complementary colors to make your product 'pop.'

Color balance: The color balance in digital photography is determined by something we call 'white balance.' Your camera should have an automatic white balance mode and several other modes you can set such as 'daylight,' 'tungsten,' 'fluorescent' and so on. Try some of these modes with your image and see which one/s work best.

The three images for this part of the assignment should be made as follows:
- Set up your props and get everything as good as you can get it.
- Take a shot.
- Do two more images, each time changing any of the visual elements listed above, and create a different arrangement of your product and props.

Look at all three images and evaluate what you changed each time. Do you think the changes made the shot better? Did you change it just enough or too much? Finally, pick a favorite and try to figure out why you like it best. Is it color, design, the message or something else? Remember this next time you have to make a similar image.

"Advertising is based on one thing: happiness. And you know what happiness is? Happiness is the smell of a new car. It's freedom from fear. It's a billboard on the side of the road that screams reassurance that whatever you are doing is okay"

— *Don Draper*

Assignment 6.2 — Create an ad

Find a product you use or like and create an ad to sell it to a specific group of people. Want to sell a smart phone? Make an ad to sell it to people between 80 and 95 years old. How about selling your car to children aged 8 to 11? Have fun with it and show us how you would approach the product and the target market.

I don't want to over direct, so take the work that you did in the first image for the product photography section and apply those techniques to creating any ad you want.

Your final image for this part of the assignment will be a single image that makes us want to buy your product. Remember that all advertising is an emotional appeal. What can you relate to your product that will make us want it? Be creative and most of all have fun. If you have fun with your photography it will come through in the final image.

Look at your image and try to come up with a tagline like the ones you would see in an ad. BTW, 'Think Different,' 'Coke is It!' and 'Sensual but not too far from innocence' are already taken. Come up with one of your own!

Assignment 6.3 — Product with Person

This image must include a product and a person. You can choose any combination you like. How about doing a shot of a 7-year old selling a chainsaw, or your mother selling condoms? The sky is the limit. Try to make us laugh or cry. Advertising is an appeal to emotion, not an appeal to logic and reason.

Most of us have seen an ad with a girl in a bikini washing a car, or a kid eating cereal, or a rugged but emotionally accessible man looking at his watch. Shoot something like that.

The biggest challenge with this image is getting the lighting right for the product and the person. You may need to place the product in slightly different light somehow. It might require a white card to reflect light from somewhere or even a black card to cast a shadow on the person or the product. Do your best with the lighting.

Also remember that you need contrast in the image. The product should not blend in with the person unless that is the point of the shot.

Your assignment is to shoot two photos with the product and the person and again, think of a slogan to accompany the images.

Assignment #7
Travel Photography

Assignment 7.1 – Photograph a detail that defines a place

The idea of this assignment is to use the skills you have been practicing in the context of travel. You can make a field trip for yourself or simply make the effort to see your local community as you would if you were a tourist.

One way to view your area differently is to ask people you know who have visited from out of town. What did they find interesting? Many times we spend our lives in a community and become inured to it even though it is home. Check with your local Chamber of Commerce for destination travel information. And, of course, you can do a Google search to see what pops out when you put in the name of the city or town and words such as 'attraction', 'sights', 'things to do' and so on.

For this first image you will want to find something to photograph that is an icon of the area. If you live in Arvada, Colorado, you might photograph the water tower. In downtown Denver you might photograph Union Station. In Golden, you could shoot the train museum or the Coors facility. You get the idea.

So go out and make a great image of something large or small that defines the place to which you are 'traveling' and we will try to guess where you were.

Be sure to use the tools we have studied. Would the image look better at night? As a close-up? Backlit? With motion blurred or frozen? Think about all these things as you create a stunning image.

Assignment 7.2 — Photograph a fun activity

In your travels, you are bound to run into an activity that will make people want to go to the place you visited. The Denver Art Museum has free art projects that you can work on. Many locations have drinking, dancing, partying or some other form of mass entertainment. Perhaps you are lucky enough to make it to a professional baseball game.

For this assignment you should shoot at least three images that bring us into the fun and excitement of your activity. Zooming your lens out to it's longest focal length will help bring us close to the action. If you can get close enough to touch what's going on, try shooting with your lens zoomed out to it's widest setting. A wide angle lens close to action tends to make us feel close and makes us feel like we are part of the action.

Try to get three different shots that are close up, overall views and reactions from people at the event.

Assignment 7.3 — Food on location

Everyone seems to be sharing their lunch on Facebook or Tumblr these days. This assignment is to create a photo of your lunch or someone else's lunch. The food should be pristine (no missing bites) and the lighting should be soft and warm (trying shooting with your camera's white balance set to 'shade.')

You really only need one shot for this assignment and there is only one requirement—the photo should make us want to eat whatever we are seeing. Try shooting close up and then make an overall shot of the plate.

If you are shooting outside, use something like a friend or a waitress to shade the food from direct sunlight. One of my favorite ways to shoot food on location is to place it in the shadow from a tree to create highlights and shadows that make the shot feel more real than just a flatly-lit burger.

Think about the best angle from which to shoot. If you are photographing a hamburger or other sandwich you probably want to be 'eye level' with the meat. If you shoot from above, people will only see bread and that's not very graphic or interesting. Pizza, on the other hand, is a definite 'high angle' shot. Hopefully this is an assignment that you can 'sink your teeth into.' Sorry, I couldn't resist.

Finally, you will probably want to arrange the food a bit to make it look as attractive as possible.

As always, remember that this is photography. It is supposed to be more fun than doing your taxes or going to the dentist. If you are not enjoying your photography you are not doing it right. At least I think that's the quote.

Assignment 8
Photo Story

Assignment 8.1 — Create a photo story

Your final assignment is to create a photo story with eight pictures. This is not a story like 'Cinderella,' but a series of pictures that shows us something about the world.

The first rule of photo story is ... don't talk about photo story. Wait, that's not it. Oh yeah, the real first rule is ... get started now, don't wait until you have a million dollar idea to begin. It's better to do another story if you have a great idea later on than to wait. You can do this assignment in one afternoon or you could spend years on it. Just remember that you'll need some time to plan and think about what you are doing to create a well-crafted photo story.

Start thinking now about what you find compelling and that you think you can make great photos of to share with the world. Pick something that is visually compelling. For example, the Denver Zoo, the Botanic Gardens, Denver Roller Girls and public art in Colorado might be good choices.

The subject does not have to be something shiny and new. If you can get access to an old warehouse or a missile silo, that might work as well.

On the other hand, you could choose to do something about how ballet dancers or football players train or the Golden Railroad Museum. The point is that you must pick something that can be represented in photographs.

When you are making the images for the story remember the craft you have been learning. Can you use photos that stop or blur motion? Can you use close-ups and macro shots? Windowlight? Night shots? Think

about all of these things as well as everything else you have learned.

Once you have created all of the raw images for the story go through and edit the set down to between eight and twelve final images. If you know Photoshop well enough, perfect them with software. Otherwise, just get them printed or create a website and enjoy sharing your images with friends, family and the whole world!

Learn by Doing • Photography 73

A Short Technical Guide

Making A Great Image Capture

Starting out with great pixels is half the battle

One of the most harmful phrases in the lexicon of photography is, "Don't worry, we can fix it in Photoshop®." Many photographers, art directors and web designers believe that anything that can go wrong behind the camera is easy to fix using software. While Photoshop is an amazing program and can fix many image flaws, it's always better to capture the image you want rather than plan on creating it in the computer. There are several reasons for this.

Not every flaw can be fixed. For example, severe over- or under-exposure will result in highlights or shadows with no detail. For many such images no amount of Photoshop magic can make the photo useable. Beyond that, though, you should not be striving for useable. If you are going to get the most out of your photos you need to be thinking in terms of getting that last two percent of image quality out of every exposure. That means good exposure, good camera support and good focus.

Another problem that can't be fixed is bad focus. There are many filters and menu selections in Photoshop that are named for something about sharpening. In fact, Photoshop cannot sharpen an image. What it does is increase contrast on the dark/light boundaries and that makes images appear sharp. If you shot the image out of focus or with motion blur, it will always be fuzzy.

There are some color issues that are difficult or impossible to fix in Photoshop. For some of them, heroic masking and local color correction might eventually get you there, but why spend hours on the computer when you can spend just minutes during the photo shoot and get it right in the first place? The fact is that in the most important ways, digital image capture is not that much different than film. Good camera technique leads to good files and that means better images.

What makes an image capture better?

Exposure

One of the most important elements in making a great image is exposure. The problem is, there is really no good way to define what is a 'good' exposure. In many cases the desired look and feel of the image may mean that the exposure you decide to make might be very different than the exposure that most photographers would consider the 'correct' exposure.

Keeping that in mind, we can define the qualities that we need in most situations. For average scenes we want to see good detail in the shadows (the darkest areas of the photo with detail), the midtones (that's usually the easy part, and the highlights (the lightest areas with detail). When we lose detail in the highlights or shadows we say that they are 'blocked up.' This means simply that they have no detail and none may be recovered using normal image processing.

Later on we will look at the 'histogram.' Just keep in the mind that the histogram is your greatest ally in digital exposure. Simply put, it is a road map that shows you where your image falls on the exposure scale. It will let you know if you are losing detail in your shadows or highlights and will also help you understand the overall 'key' (key is a way of explaining the brightness or darkness across a whole image) of your photograph.

While we don't want to limit your photography to average scenes, keep in mind that just saying "That's the way I wanted it!" is no excuse for badly exposed photos. It might be difficult to define good exposure, but bad exposure is easy to define when you see it.

To create any exposure we must balance four things, all equally important: the light that exists or is added to a scene; the size of the opening that lets light into the lens; the amount of time light is allowed to pass through the lens; and the sensitivity we assign to the camera chip.

Aperture

The opening that lets light into the lens is called the aperture (Notice that there is only one 'a' in that word, it is not aperAture!) The word aperture comes from the Latin *apertura* which means opened or to open. So the aperture is an opening in the lens.

Because we use various lenses, we need to have a way of knowing

when the same amount of light is passing through different lenses. We call this notation an f-stop. Because an f-stop is a ratio of the lens opening to the length of the lens, the same f-number on different lenses will always admit about the same amount of light. In other words, if you have a 15mm lens and set it to f/8, it will let in the same amount of light as f/8 on a 500mm lens.

One last feature you should know about f-stops is that your choice of f-stop doesn't just determine the amount of light you let in through the lens. It also makes a difference in the focus of your image. A larger opening in the lens lets in more light, and at the same time it means that less of your image will be in focus in front of and behind what you actually focus on. So, if you want to blur the background (what is behind your subject) use a large opening in your lens.

Shutter Speed

In every camera there is some kind of device that allows light to strike the camera chip for a precisely measured amount of time. We call this the shutter. The shutter opens and closes and must be accurate to very small fractions of a second.

Shutter speed is what we call the amount of time the shutter remains open. Shutter speeds can range from small fractions of a second to several hours. The faster the shutter opens and closes the better we freeze action. The problem is that a fast shutter speed also means that we get less time for light to enter and create an exposure.

Slower speeds are good for capturing subject that don't move much and for things like flowing water. By using a shutter speed that is relatively long (such as a second) you can render flowing water as a pleasing blur in the image. The choice of shutter speed when photographing flowing water is one thing that helps define a nature photographer's 'style'.

ISO

The third thing that we can use as a creative tool while we are photographing is ISO. ISO stands for 'international standards organization' and is simply a way of having a common way for describing the sensitivity of a camera chip (or of film) so that we can have an idea of the how much light it will take to make an exposure. For general photography you should keep your ISO set at the smallest number available on your camera. For some cameras that might be 100 and for others it could be 200.

Whatever happens to be the smallest number in the list of ISOs on your camera is fine.

There are times when you might want to use ISO as an exposure tool in addition to shutter speed and aperture. The main reason to increase ISO is that you are in a low light situation and reach the limits of your camera's shutter speed and aperture. If you need a faster shutter speed to stop the action at a sporting event or even a wedding, you can change your ISO to a higher number, making your camera more sensitive to light and allowing you to shoot in darker situations.

The problem with using a higher ISO number is that you will start to see specks of incorrect color in parts of your image. We call this 'noise' and when it becomes noticeable, it can make images unusable. On the other hand, if your choice between missing an important image and having to live with some noise in the photo, it is best to just pick a higher ISO number and get the shot.

Sharpness

When every part of your image that you wish to have crisp detail does have crisp detail we say that the image is 'sharp.' Like exposure, sharpness can be somewhat subjective. In other words, you might intentionally allow some things in your image to have less detail because you want to remove emphasis from them.

Sharpness is controlled by focusing the camera, by your choice of lens aperture, by your shutter speed and also by the stability of your camera. When looking at an image that lacks sharpness we can often determine which of these items was lacking when the photo was made. In order to get good sharpness make sure you focus critically, use as fast a shutter speed as possible and always use a tripod or other camera stabilizer if you can.

Best Moment

Making great photos is all about timing. Most photographers make a few great images in a whole lifetime. Some make dozens or hundreds but, spread out over many years, that is still not a lot of perfect photos. It is worth the investment of your time to wait until the conditions are perfect to make your photo. The best nature photos are generally made during the early morning (around sunrise) or the late afternoon (near sunset).

Animals feed around dusk and the warm glow of a setting sun makes nearly any landscape look more appealing. If you want to do nature photography, you need to wait until conditions are perfect and that may mean standing next to your camera for several minutes or several hours. If you get a great photo, the time will be worth it.

When shooting sports, fashion, portraits or anything else involving people, waiting for the right moment is even more critical. By watching and waiting (instead of just pushing the shutter button and shooting dozens of frames hoping for one good one) you can anticipate the peak of action or the best expression and capture it. Even a very high speed camera will seldom capture that one perfect frame where everything is right. Your camera doesn't have a brain that can see an image come together and know when all the elements are exactly the way you want them to be. With practice, you can capture that perfect moment time after time and create a body of images that will make you both proud and respected.

Best Lighting

There are five qualities of light to which you should pay attention whenever you are making a photograph. They are: brightness, color, contrast, specularity and direction.

Brightness

Brightness is simply the amount of light falling on the scene. Is there enough light to make a well exposed photograph? Do you need to use a tripod to avoid blur because the light is too dim? This is the aspect of light that we almost always evaluate first. We typically measure the brightness of a scene use a light meter.

Your camera probably has a light meter that has different settings such as 'spot,' 'centered weighted' and 'matrix.' Your meter is most likely attached to your camera's shutter and aperture controls and can make automatic adjustments to create the exposure the camera's computer calculates for the light in the scene and the subject. In many cases the exposure your camera sets is perfectly adequate. In some cases the meter and computer will be fooled into making an exposure that doesn't express what you want to say about the scene. In those cases you will need to set your camera controls by using the 'manual' exposure control

on the settings dial.

Some light meters are hand-held units that are separate from the camera itself. There are advantages to using a hand-held meter such as the ability to read a smaller portion of the scene (some meters are called 'spot meters' and read only about 1 degree of the scene) and the ability to be carried to the subject while your camera rests some distance away on a tripod.

Color

The color of light is defined in photographic terms using Kelvin temperature. We describe daylight as being about 5000° Kelvin; light bulbs in an average lamp are about 3200° Kelvin and candle light is about 2900° Kelvin. When our eyes are exposed to different Kelvin temperatures of light our brains automatically compensate to make the whites look white and the grays look neutral. Your camera must be set at a color temperature that works with the light you find yourself in. We do this by 'white balancing' the camera. There are a number of ways to white balance and we will address them later in this chapter.

Contrast

The contrast in an image is a way of describing the range of brightness between the brightest highlight and the darkest shadow. An image that has bright highlights and dark shadows is said to have a high contrast range; conversely, an image where there is a smaller difference between the highlights and shadows has low contrast.

While we often look at overall contrast in an image, we also look at what we call 'local contrast,' that is, the range of tones within a smaller part of the overall image. An image might be all gray but have a face in the center that is much lighter. The over contrast of the image would be low, but the contrast around the face would be high.

Specularity

We also look at light in terms of how focused the illumination source is on your subject, and also how large the source of light is in relation to the subject. When a light source is large compared to the subject we usually describe the light source as 'soft' or diffuse. On the other hand, a small light source shining directly on a subject would be described as 'specular.' Diffuse light sources produce lower scene contrast than specular sources. Many photographers use devices on their camera flash and

other light sources to spread the light out and make it 'softer.' This results in a more flattering representation of people and products.

Direction

From where is your light coming? We talk about the direction of light by describing where it comes from in relation to the thing you are photographing. Does the light come from behind the subject (back lighting) from the side (side lighting) or from the front (you guessed it, front lighting)? We can make photographs using each of these directions and they will all highlight different aspects of the subject.

Front lighting tends to flatten out detail because it produces fewer shadows, and shadows are what create detail in a photograph. Back lighting, used by itself, will create a silhouette of your subject with little detail. Side lighting accentuates the surface detail of your subject. Try photographing an orange (or other textured object) some time using light from these three directions. Look closely at the finished photos and you will see the difference lighting direction makes.

A word about front lighting

When in doubt, think about the main subject of the photo you are making and be sure the brightest light source is illuminating that side. In other words, if you are photographing a building, you want the light to be hitting the front to show its detail. If you are photographing a shoe, you want to put light on the part of the shoe to which you wish to draw the viewer's attention. The human eye will usually look to the highest contrast in an image. If you have something in the middle of your photo that is light against a dark background, people will tend to look at that first.

Best camera angle

When you are making a photograph don't just walk up to the subject and start snapping away. Take the time to decided what you want to show in the image. What is the most important thing in the frame, or what is the most important idea you want to communicate?

You may choose to place your camera above the subject, below it, at the subject's level. Perhaps you want to photograph from behind or shoot straight down on something. The most important consideration is, what

do you want to emphasize in your image? If you shoot your subject from a high angle you will reduce the background. On the other hand, if you want to show your subject in public or in a natural setting you will want to shoot straight on toward the subject or at a low angle to include background elements.

The most important thing is not to always just put your camera on the tripod at your eye level and make a photo. Think about what the camera angle you select adds to your composition.

Single idea per image

It is common to photograph more than one thing at the same time. We do this to show comparison and contrast the subjects of the photo to each other. Unless you are making a comparison, however, you should be thinking about removing anything from the frame that doesn't support the one key idea you are trying to communicate in your photograph.

If you are making a portrait you will generally want to make sure the face of the subject is featured. If there is a plant, a window or a dog in the background it will distract from the face (the idea you are trying to capture).

Simplifying the image you are making by excluding unwanted items can make an image much stronger. You can simplify your image by choosing a zoom setting on your lens, walking closer to your subject or changing camera angle. Ralph Gibson, a master fine art photographer, once said, "Remove everything you don't want from your image until you can sign your name to each square inch of the finished print." In other words, make sure that everything in the photo is there because you wanted it to be, not because you weren't paying attention or didn't care.

Metering

Before making any exposure with your camera it is necessary to have your light meter evaluate the amount of light available to make the image. You can either use your camera on an automatic setting, in which case the camera makes the choices for you, or you can set everything

yourself after taking one or more readings of the light in order to assess whether a good exposure can be made, and how to best set your camera.

In some situations you have little choice but to use automatic settings. If you are shooting a breaking news story in changing light (for example, you might be following people inside and outside at an event) it would be nearly impossible to spend time taking meter readings and calculating the perfect combination of shutter and aperture.

Even in these situations, though, you can exercise control by setting your camera on 'program' mode. Most cameras have a wheel or dial that keeps your exposure correct but changes the aperture and shutter speed. In this way you can select an aperture (to control what is in focus) or a shutter speed (to freeze action) without having to figure out how to balance the exposure yourself. Even using the automatic settings on your camera, you must still tell it how to make it's readings. You do that by selecting one of the camera's 'metering modes.'

Metering modes

The meter in your camera (called a 'reflected light meter') can make readings in different ways in order to accommodate different lighting situations and different preferences of the individual photographer. The various metering modes are mainly differentiated by the amount of the scene in which they read the light, and by the way they set the camera based on that information. Hand-held light meters sometimes read reflected light (most of these are called 'spot meters') but generally they read the light that falls on them and we call them 'incident' light meters.

Average

The most common type of averaging meter is called a 'center weighted' meter. Most of these meters analyze a part of the frame that comprises around 60 percent of the whole scene. Like nearly all light meters, the meter averages this part of the scene and provides an exposure that will render the scene as a middle gray. This gray is also called 18 percent gray. The problem with this approach is that some scenes have something very bright or very dark in the middle and that can throw the average off resulting in a poor exposure.

Computer averaged or matrix

The next version of the camera light meter is similar to the averaging meter except it typically reads more of the image area and then uses

sophisticated software to guess at the proper exposure. Computer aided meters try to take things into account such as your subject, the brightness range in the overall scene and in some cases your preferences. Matrix metering is generally more accurate than simple averaging because it takes the subject into account.

Specialty camera modes

There is a dial on top of most digital SLR cameras (and often a menu in point and shoot versions) that permits the selection of specialized exposure modes. These include night shooting mode, portrait mode, backlight control and others. These specialty modes are simply computer programs that set the camera controls in ways that work for the situations for which they were programmed. For example, 'portrait' modes typically set the camera to a large lens opening (to limit what is in focus behind the subject) and as fast a shutter speed as possible (to control subject motion). Many cameras have a sports mode which will set the fastest shutter speed possible in order to freeze fast action. Read your camera manual to determine which specialty modes are available and what they do.

Spot metering mode

The spot metering mode takes a meter reading that evaluates a small area of the image (typical in-camera spot meters read between 3 and 7 percent of the total frame). This is valuable because it gives you information about the light that is reflecting from the subject and reaching the camera. A skilled photographer can obtain very precise exposure readings using the spot meter mode. It takes practice and is mostly used when very precise control is desired and there is time to make at least a few readings to help guide the manual setting of a camera. The spot meter does not provide an exposure that can be directly set on your camera unless you are pointing it at something that is exactly middle gray. We will talk more about spot meters when we get to the Zone System.

Light

Reflected Light versus Ambient Light

As you make a meter reading you are reading one of two types of light. Reflected light means light that is bouncing off the subject directly into

the camera lens (and meter). Ambient light is the light falling on the subject and is typically read by a hand-held meter made for taking such readings.

Ambient Light versus Added Light

Ambient light means the light that is just falling on your subject naturally. It can come from any source such as light bulbs, the sun, a fire or even a candle. Ambient comes from a Latin word which means 'going around," so ambient light is the light that is around your subject without you adding or changing the illumination. Added light is any flash, hot light or other source that you add to the scene to increase the light level or modify the existing light make it look better. This might mean adding light from the side to bring out the texture of something or simply adding flash to freeze action or provide a better color balance to the scene.

White Balance

When we talk about white balance we are really just referring to a color balance in the photograph where the neutral tones (black, white and gray) are made up of equal amounts of red, green and blue. If you have a place in your image where there is an equal amount of these three colors, this is by definition neutral color balance.

Color balancing photos simply means finding a way to make the colors in the image look the way you want them to look. Flesh tones are among the most important because all humans know what skin looks like. Neutrals (grays, blacks and whites) are also important because our brain has an automatic balance for them. Other colors are more difficult to get right. What does a blue sky look like? There is a range of blues that might be considered correct for sky colors. Even colors like 'fire engine' red can have too much of another color in them and still look right.

When we are making photographs, we try to create correct color in the image when we record it. The technique we use to do this is called 'white balancing.' Your camera probably has several modes under the heading of white balancing. These include AWB (automatic mode), daylight, tungsten, fluorescent and custom. As with automatic light metering, allowing the camera to balance the color automatically creates an average balance that works much of the time but not always. If you know what kind of lighting you are in you can select a mode such as

'tungsten' if you are shooting under the light of ordinary light bulbs. The best approach to light balancing is to photograph a known reference in the same light as photos you are making and then use that reference for color balancing in the computer. With many cameras it is also possible to photograph a reference card such as a gray card or WarmCard™, and set the resulting images as a reference in your camera. Either of these methods work very well.

What is RGB and why do we use it?

When we talk about color we refer to it in terms of a "color model." A color model, or color space, is a way of referring to all of the colors available in a particular device. These devices may include your eyes, a camera, a printer, a computer screen or your phone. Each one can display a set amount of colors. One of the great problems of digital photography is to make images look good in different color spaces.

One of the most widely used color models is 'RGB.' This stands for Red, Green, Blue. The reason these colors are the basis of most color models is that they are the colors which the cones in our eyes can see.

Another common model uses the complement to the RGB colors. It is called CMY or CMYK. The colors represented by this model are Cyan (a bright blue color), Magenta (a bluish red, or 'hot pink') and Yellow (just what you think it is). The last color is Black which is indicated by the letter 'K'. This stands for "key" because the in four-color printing process the cyan, magenta and yellow printing plates are keyed (or aligned) with the key of the black plate. Computer monitors are also set up to create color using RGB colors. When creating photographs to be viewed on a television, computer or phone, they should be saved in the RGB color space.

Basic Zone System

The Zone System was originally formulated by Ansel Adams and Fred Archer in 1941. Their idea was to create a systematic way of handling all the variables in film photography. At the time film speeds were not very reliable, papers varied radically from batch to batch and so on. In order to make high quality photography more repeatable, Adams and Archer used a variety of tests and light metering routines that lead to generations of photographers filling notebooks with information about their

images. Since we no longer need to deal with film, developer or paper in the digital photographic arena, we will be using a very limited set of ideas about tonal control that are applicable today.

One of the first tenets of Adam's system was that you should test everything and make sure your camera shutters, lenses and meters were working properly. This is as valid today as it was in 1941. If you ever use your cameras to make money, be sure to have them serviced and checked out annually. If you don't use your camera for a while, remember to remove the batteries. Corrosion from leaking batteries can destroy the inside of a camera.

The choice of exposure settings and making appropriate meter readings is the next step. Zone System photographers always use a reflected light meter. This is because it allows you to evaluate the reflectance of your subject in addition to the light falling on the subject. Most Zone practitioners use meters that read just one degree of the subject, making the readings very accurate and allowing readings of very small areas of the image.

Your camera probably has a spot metering mode. The disadvantage to using the in-camera spot meter is that it usually reads an area that is more like 3.6 to 12 degrees (depending on the camera and lens). This means you have to be a bit more careful how you make the reading. You will want to get as close to the subject as possible to make sure the tone you are reading fills the camera's spot meter frame.

Once you have made a reading you will need to interpret what the meter has told you. All meters provide exposures that reproduce your subject as a middle gray tone. In order to create a good representation of your subject from a spot reading, you will have to determine how far the subject's reflection falls from the meter reading.

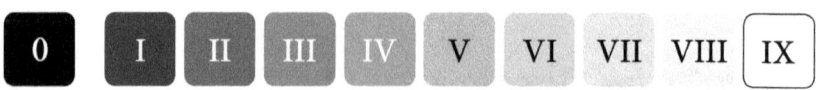

We typically speak of zones in the Zone System as representing one whole stop of tonal range. Most versions of the system describe the image in terms of ten zones numbered from 0 to IX. Zones (except 0) are always represented by roman numerals. We define zone 0 as the darkest black we can reproduce in any system. It is black with no detail.

At the other end of the scale is Zone IX, which is completely white. This is sometimes called 'paper base white' because it is the whitest tone you can get—the base of the printing paper represents that upper

limit of tonality.

Zone V comes in at the middle as the gray that is halfway between the extremes. Since many scenes average out to a middle gray tone, some photographers use a gray card to meter from and calculate their exposures.

The two most important zones are Zone III and Zone VII. Zone III represents the darkest thing in your photo where you want to maintain some detail. Many traditional Zone System workers used this as the basis for their exposures. On film at least, if you get the minimal shade detail, you probably have a printable negative. This approach actually works just as well with digital exposures.

If you look at your scene and choose the darkest area with detail you can make a spot reading then set your camera to give two more stops of exposure and you will get a perfect capture in most situations.

At the other end of the exposure scale is Zone VII. This represents the lightest highlight with detail. If you are photographing a bride and want to make sure you get detail in the wedding dress, take a spot reading from the dress then close down two stops and set your exposure.

Average Caucasian skin tone falls around Zone VI. If you take a reading off the face of a Caucasian portrait subject then open up one stop, you will get a perfect exposure.

Snow is difficult to read but also works well as the source of a zone reading. Point your camera at a clear, evenly lit area of snow and take a reading. Now close down a stop and a half and you should get a good rendition of the snow that is white, but still retains its detail.

ISO-Based Exposure

There are situations where the use of a light meter is difficult or produces results that are difficult to understand. In those cases, some professionals revert to a method of exposure determination that has been around since the beginnings of photography. This technique can often be more accurate than a light meter and it is simple to use once you learn it.

ISO-based exposure takes advantage of the fact that the sun puts out a constant amount of light as long as it is shining in a clear blue sky, and more than 20° above the horizon.

Since the light of the sun is a constant reference, we know from testing that if your camera is set to an ISO of 100, then the basic exposure

should be f/16 at 1/100 of a second, or the nearest available exposure. In other words, at times when you have an average sunlit scene, you can expose for f/16 at 1 over the ISO and get a correctly exposed image. In many instances your camera would be fooled but using the ISO method may get a better image.

Using this basic reference, we can also make photographs in other lighting situations by figuring out how far they are from our reference exposure. The following table shows a variety of lighting scenarios and how many stops of light you need to add or subtract from your basic exposure to get a good photo.

Estimating 20° above the horizon. Extend your arm straight out in front of you and spread out all five fingers as shown. The tips of the thumb and little finger should form a line perpendicular to the horizon line. When your little finger is touching the horizon, the tip of the thumb will be approximately 20° above the horizon.

In addition to helping with exposure in difficult situations, ISO-based exposure can also be used to make sure your light meter is working. Once you understand the system you can quickly calculate about what the exposure should be in order to make sure your camera or hand held meter is not giving you the wrong setting.

ISO-Based Exposure Chart

Type of scene *Exposure change*

Normal subject in sunlight .. None
Dramatic effect or silhouette effect, shooting directly into the sun − 2
Bright snow or sand .. − 1
Backlit subject, exposing for shadow area, portrait, etc + 2

OVERCAST
Weak, hazy (very soft shadows) ... + 1
Normal, cloudy, bright ... + 2
Heavy or open shade .. + 3

NIGHT − OUTDOORS
Brightly lit theater districts (Las Vegas, Times Square, etc.) + 6
Brightly lit downtown street .. + 7
Store windows .. + 6
Neon signs; other lighted signs .. + 5
Flood lit buildings, fountains ... + 11
View of city skyline .. + 13
Firework displays on the ground ... + 6
Fairs, amusement parks .. + 8
Sporting events (football, baseball, race track, etc.) + 6

NIGHT − INDOORS
Stage shows
 With bright light ... + 5
 With average light .. + 7
 Flood lit acts (ice shows) .. + 6
 Flood lit acts (circus, etc.) .. + 7
Sporting events (hockey, bowling, basketball, etc.) + 7
Swimming pool − tungsten lights .. + 8
Office − fluorescent lights ... + 6
Home − areas with bright light .. + 8
Home − areas with average light .. + 9.5
School − stage and auditorium ... + 9
Churches − tungsten lights ... + 9
Christmas lights, indoor or outdoor ... + 10
Candle-lit close-ups .. + 10-11

Camera Stabilization

Many things can degrade the sharpness of a photographic image. One of the most common is 'camera shake.' It is nearly impossible to hand hold a camera and get really sharp images. Even if you hold your breath your body is in constant motion. The motion may seem small to you as you stand there with the camera, but even a tiny amount of movement will cause a noticeable degradation of image sharpness.

A tripod may not be able to fix the problem entirely, but it is a good step in the right direction. Even with a tripod there is transmitted ground vibration, camera shake caused by pushing the shutter release and even wind buffeting of the camera.

Here are some things that can help:

- Use a remote release to trip your camera's shutter. Most cameras can use a radio, infrared or wired remote.

- If you don't have the money for a remote camera trigger, use your self timer. Set the timer to trip the shutter after 10 seconds. This will allow camera movement caused by pushing the shutter button to stop before the shutter fires.

- If there is a large gust of wind, or if a large vehicle passes you, wait a minute or two for the ground to stop vibrating.

This may seem extreme, but if you want to get images that are world class, you have to start by investing the time and effort to make sure they are as technically proficient as possible.

Tripod

A cheap tripod is never a bargain. If you can't afford a good tripod, any tripod is better than hand holding. Generally speaking, the heavier a tripod the better. When you are shopping for tripods, look at how the leg extension locks function. They should be smooth and simple to operate but they should also lock in place securely.

Keep your tripod maintained. If you use it outdoors, make sure you wipe it down and keep it clean and dry. Some tripod models come with tools to adjust the legs and head. Make sure you keep them tight enough to hold your camera securely.

Many tripod models have rubber feet that screw up to reveal metal spikes. The idea of this is that the spikes will stick into the ground and create a better footing in dirt. If your tripod has these spikes, make sure the rubber feet are screwed all the way down to cover them before you shoot indoors. Nothing is quite as embarrassing as ruining someone's hardwood floor with your tripod spikes. You don't want to have to spend your photography fee having someone fix the scratches.

Monopod

In some situations a tripod is just not practical. If you are photographing a sporting event and have to run up and down the sidelines following the action a tripod just won't work.

In these situations you can get better stability using a monopod. This is simply a one-legged tripod. Obviously it won't stand on its own, but you can use your own legs as the other two tripod legs and hold the camera on the monopod. The monopod stabilizes the camera in the vertical plane and removes a good portion of the camera shake.

Rice bag

If you can't carry a tripod you can try a rice bag. Perhaps you are going on a backpacking trip and can't afford the weight and bulk of a tripod. A one- or two-pound bag of rice can be a big help in this case. Buy the rice and then wrap it in several layers of duct tape. This will create a malleable surface on which to place your camera. Place the rice bag on a stable surface such as the top of a car (make sure the engine is off), a cement fixture, a tree branch or log, a large flat rock or other secure location. Place your camera on the bag and grind it a little to make it seats in the rice bag. Stay close—a rice bag may not be secure enough for you to leave it. Use the self timer and you should get a steady shot.

Pressing against a stable object

If you have nothing else you can try pressing your camera against any stable surface. Put some weight on it to hold it steady and use the timer to trip the shutter. This technique is surprisingly stable. A friend of ours once made photographs inside the pyramids in Egypt using this technique. He made exposures up to 4 seconds long with little or no camera shake. It takes practice, but it can be a good technique when the need arises.

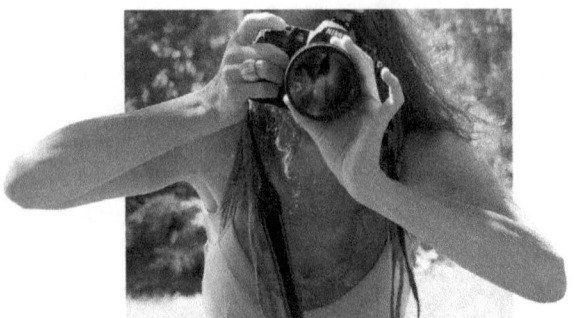

INCORRECT The 'funky chicken'

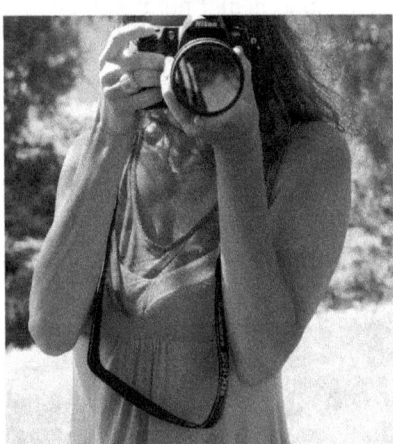

CORRECT Elbows tucked in tightly

Stable hand holding

The last resort in image stability is to hand hold as carefully as possible. If you must hold your camera, you will keep it steadier by making sure you don't do the 'funky chicken' with your arms. Keep both elbows tucked in as tightly as you can to maintain the maximum possible stability.

Using the IS mode on a lens

Many modern cameras and lenses are equipped with an image stabilization (IS) mode. Some work better than others but we are up to about the third generation of these systems and they have improved greatly since the days of their introduction. The only thing to be careful of with theses devices is that they consume battery power. If you are in a situation where you have to get all of the exposures possible out of a battery charge, avoid using the image stabilizer.

About Light

There are four qualities of light to which you should pay attention whenever you are making a photograph. They are: intensity, color, source size and direction.

Intensity

The intensity or brightness is simply the amount of light falling on the scene. Is there enough light to make a well exposed photograph? Do you need to use a tripod to avoid blur because the light is too dim? This is the aspect of light that we almost always evaluate first. We typically measure the brightness of a scene using a light meter and often describe it in terms such as 'hot' or 'bright' or 'powerful.'

Your camera probably has a light meter that has different settings such as 'spot,' 'centered weighted' and 'matrix.' Light meters give us the intensity of light in units called lux or footcandles. Your meter is most likely attached to your camera's shutter and aperture controls and can make automatic adjustments to create the exposure the camera's computer calculates for the light in the scene and the subject. It does this by setting the aperture and shutter speed to create an average exposure for the light in front of it. In some camera modes you can select a different shutter speed or aperture and the camera will automatically change the setting to compliment the setting you chose and create the camera's idea of a 'correct' exposure.

In many cases the exposure your camera sets is perfectly adequate. In some cases the meter and computer will be fooled into making an exposure that doesn't express what you want to say about the scene. In those cases you will need to set your camera controls by using the 'manual' exposure control on the settings dial.

Some light meters are hand-held units that are separate from the camera itself. There are advantages to using a hand-held meter such as the ability to read a smaller portion of the scene and the ability to be carried to the subject while your camera rests some distance away on a tripod. One type of light meter is called a 'spot meter' and reads an area that includes only about only about 1 degree from the overall scene.

Color

The color of light is defined in photographic terms using Kelvin temperature. We describe daylight as being about 5500° Kelvin; light bulbs in an average lamp are about 3200° Kelvin and candlelight is about 2900° Kelvin. When our eyes are exposed to different Kelvin temperatures of light our brains automatically compensate to make the whites look white and the grays look neutral.

The brain has references that make a color look the same under different illuminations. There are three of these reference, one for white, one for black and a less effective one for gray. The eye is most sensitive to 555 nanometers (lime green).

Your camera must be set at a color temperature that works with the light in which you find yourself. We do this by 'white balancing' the camera. There are a number of ways to white balance including photographing a reference card, setting a specific white balance or using the camera's automatic function.

Source size

This describes the size of the light in relationship to its distance from the subject. The sun is immensely large, but because it is so far away, it appears small compared to the size of your subject. On the other hand, a 2-foot wide softbox appears huge when it is a few inches away from the subject. When the source is small, the light casts sharply defined shadows. This light is called "hard light." Sometimes you may hear this referred to as specular, but this should be avoided, because it can be confusing when you apply it to incident light.

When the source is large, it casts shadows that are not sharply defined. This is described as "soft light." The 'hardness' or 'softness' of a light source is not directly related to diffusion. A diffuse light source that is placed far from the subject will become a hard light if it is far enough away.

The contrast in an image is a way of describing the range of brightness between the brightest highlight and the darkest shadow. An image that has bright highlights and dark shadows is said to have a high contrast range; conversely, an image where there is a smaller difference between the highlights and shadows has low contrast.

While we often look at overall contrast in an image, we also look at what we call 'local contrast,' that is, the range of tones within a smaller part of the overall image. An image might be all gray but have a face in

the center that is much lighter. The overall contrast of the image would be low, but the contrast around the face would be high.

Many photographers use devices on their camera flash and other light sources to spread the light out and make it 'softer.' In other words, photographers have a variety of devices that make small light sources act like they are larger in relation to the subject. They usually do this by 'bouncing' light around so that it spreads out faster than it would if it were coming straight from the flash or strobe head. This results in a more flattering representation of people and products.

Direction

From where is your light coming? We talk about the direction of light by describing where is comes from in relation to the thing you are photographing. Does the light come from behind the subject (back lighting) from the side (side lighting) or from the front (you guessed it, front lighting)? We can make photographs using each of these directions and they will all highlight different aspects of the subject.

Front lighting tends to flatten out detail because it produces fewer shadows, and shadows are what create detail in a photograph. Back lighting, used by itself, will create a silhouette of your subject with little detail. Side lighting accentuates the surface detail of your subject. Try photographing an orange (or other textured object) using light from these three directions. Look closely at the following three photos of an orange and you will see the difference lighting direction makes.

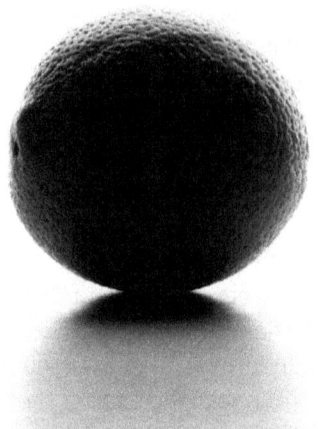

Orange #1 — Back Lighting
This image of an orange was created using a large light source which was located directly behind the orange. The main part of the orange is dark and shows little detail. In the real world, back lighting doesn't produce a complete silhouette, it usually creates a highlight showing detail around the outside of the subject. When you look at the edges of the orange peel you can see good color rendition and detail. Photographers use this type of light to create visual separation between a subject and the background. Without separation light, the subject will often become the same color and density as the background, creating a 'tonal merger' and making it difficult to tell where the subject ends and the background begins.

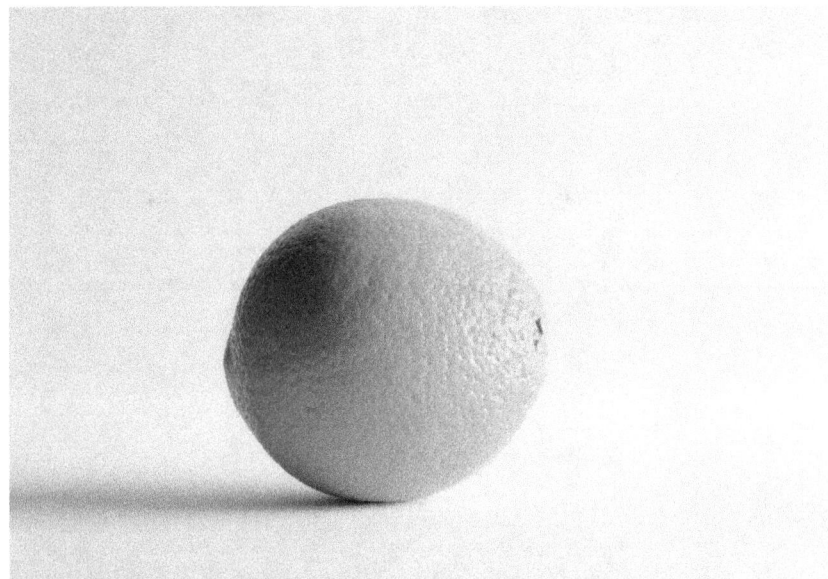

Orange #2 — Side Lighting

By moving the light to the side, we create better color rendition and a sense of the roundness of the orange. Since shape is shown by creating shadows, photographs made with the light source to the side help us illustrate the dimensionality of our subject. In addition, shadows show us detail. The skin of the orange has indentations that create texture and by lighting from the side we create shadows that allow us to capture these features.

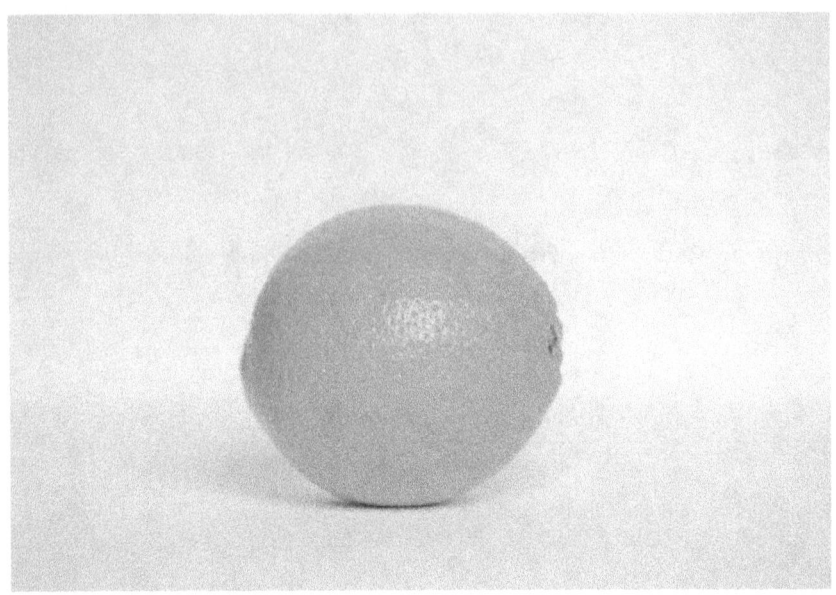

Orange #3 — Front Lighting

Placing the light directly in front of the subject makes the overall tone very smooth and reduces detail because there is little shadow area to show us the subject surface. In photography, light from the front is usually used along with at least one other light in order to create the desired tone in shadow areas. A light placed on the side creates strong shadows and when a light is placed in front and then balanced it can leave some shadows to create shape and texture while bringing illumination to keep the shadows from concealing too much information in the photo.

Aperture, Shutter Speed and ISO

There are three basic camera controls that determine how dark or light your image will be when you make your image capture. There are other controls such as your camera modes, but even the camera modes use these three basic tools to create an exposure.

You can think of three things like the legs of a stool. If they get out of balance you can't sit on the stool. You must always maintain a proper exposure to keeping the three exposure elements in a working relationship to each other.

One guiding principle helps you to maintain this balance. Each of the three main elements changes in the same way, so that if you change the shutter speed, aperture or ISO by one unit, you can change one of the others by the same amount and always maintain a balance.

Shutter speeds are just called 'shutter speed or speed,' Apertures are called 'f/stops' or 'lens openings', and ISO is mostly called 'ISO' or 'chip speed.'

While your camera might show a variety of numbers to represent your shutter speed and aperture, there is a series of speeds and f/stops that are called 'whole stops.' Whole stops all allow twice as much to enter the camera as the stop below and half as much as the stop above. This means that if you change your ISO, speed or aperture by a whole stop, you can always keep the exposure in balance by changing another of the exposure elements in the opposite direction.

For example, if you let 1 stop more light in with the shutter speed, you can balance the exposure by letting in 1 stop less light with the aperture.

Because of this relationship, it is important to remember the whole shutter speeds and whole f/stops. The display in your digital camera reads out exposure information exactly as the computer in the camera sees it. Unfortunately, this does not give you the whole stop information, you must learn to look at what your camera is reading out and figure out what whole stops you are closest to in order to create good exposures.

Aperture

The dictionary defines *aperture* as a hole or opening. That is exactly what the aperture in your camera lens is. It is an opening through which light can enter so that the chip in your camera can record the image you are photographing.

The size of this opening is critical for two reasons: 1) If the opening is too large or too small, your photograph will be too dark or too light and you won't record details of the image that you want to have.

2) The size of the opening determines what will be in focus in front of and behind your main subject. This range of focus covering the depth of your image is called 'depth-of-field.' If you don't have enough depth of field, the background of your image will be out of focus and it will be difficult or impossible to make out details in the background. Sometimes that is good, but you want to control it by choosing an aperture that provides the background (and foreground) focus you want.

The lens opening

How wide your lens opens is determined by a set of blades that close to form an opening inside your lens which determines how much light gets in.

We describe the size of this opening by calling it a number with the letter 'f' and a slash before it. For example, f/8. The number is a ratio of the size of the actual opening to the focal length of the lens. This means that an f/8-sized opening fits eight times along the length of the lens; and an f/2 opening would fit only twice in the length of the lens. So, the smaller the f/number is, the larger the actual opening because the higher the number, more circles have to fit in the length of the lens.

If you look into your lens and watch the blades close down as you make an exposure, you will see that with your lens set to something like f/5.6, the opening in your lens will be almost as large as the outside diameter of the lens itself, while f/16 will be about the size of a pencil eraser.

The whole f/stops

While your camera reads our a large variety of numbers corresponding to this opening, we describe the 'whole f/stops' as being a list of numbers based on a starting point of f/1 and adding numbers which give us half as much light entering the camera as the previous number. This sequence of whole numbers looks like this:

f/1 f/1.4 f/2 f/2.8 f/4 f/5.6 f/8 f/11 f/16 f/22

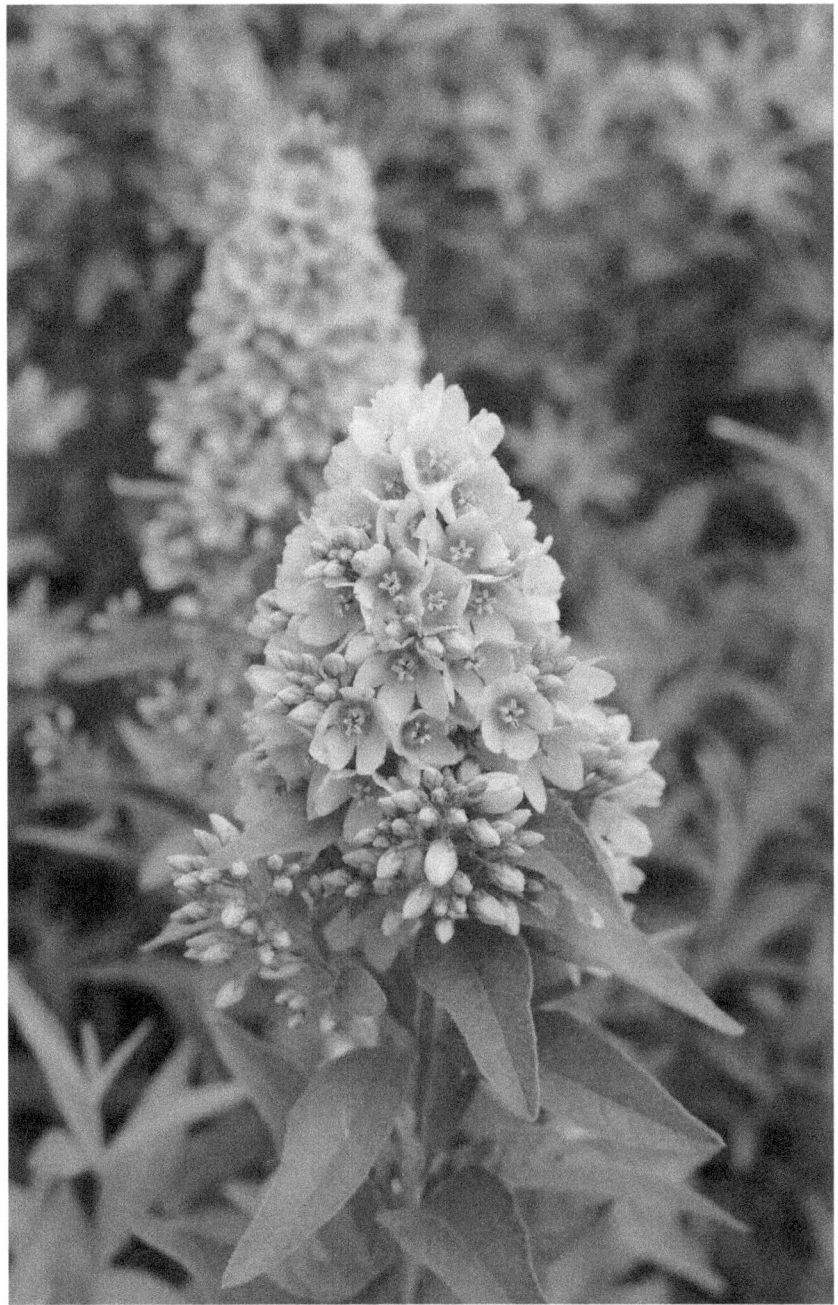

Depth of Field is the range of focus covering the depth of an image.

For a complicated mathematical reason, the numbers don't simply double as they go up, but each number along the line allows half as much light to strike the camera chip as the one to its right, and half as much light as the one to its left. Therefore, f/5.6 lets in twice as much light as f/8, and half as much light as f/4.

The problem is that your camera often reads out something like f/6 or f/9. These are not whole stops and in order to make sense of the exposure if you want to set it yourself, you have to round the exposure the camera give you up or down to the nearest whole f/stop.

So, if your camera tells you it is set at f/9, you can look at the chart (Hopefully you will memorize the whole stops so you just remember which one to round to.) and decide that the nearest whole f/stop is actually f/8. If your camera tells you that you are shooting at f/12, you can round it to f/11. By always thinking about your exposure in whole f/stops, you can change your exposure much more easily to obtain the image characteristics you desire.

Some f/stop suggestions

In some photographs it is necessary to use f/stops to create a specific result. Sometimes you may want to use a particular f/stop. Keep in mind that all of this is subjective and that you may want to use a different f/stop to obtain another artistic interpretation of the subject.

Selecting f/stops in portraiture

There are two general types of portraits. In most cases we want to keep attention on the face of the subject. This means trying to limit the amount of detail in the rest of the photograph. The way we limit the amount of detail in the background of an image is to use a large opening in the lens. This means a lower f/number (f/5.6 or even lower, if available). Be careful when using a very large lens opening for portraits, however, they can create problems you may not expect. At f/5.6 you probably won't encounter any issues, but if you have a 'faster' lens (that is a lens with a smaller available f/number such as f/2.8) you can actually have depth-of-field that is so limited you can focus on someone's nose and have their ears be out of focus. If you are using a fast lens, make sure you check the results before you let the subject leave.

The other main portrait situation is an editorial portrait in which we include the background and foreground to show the subject in their environment. You may photograph a chemist and want to include lab

equipment to give people a sense of who they are and what they do.

In this case, you will want to use a smaller lens opening. This means a larger f/number such as f/11 or f/16. Use of such a small aperture in portraiture can cause another problem. If the light in the place in which you are photographing is average to dim in intensity, you may not be able to use a shutter speed that is fast enough to prevent blur from subject motion or camera shake.

If you find yourself in this situation there are two possible solutions. First, you can add light to the photograph by turning on more room lights or adding photographic flash. Using flash can make your photo look staged if you don't know how to use it well so turning on more lights can often create a more pleasing image. The second possibility is to increase your ISO. Each time you double the ISO number you make it possible to increase your shutter speed by one whole speed. This can help to keep your portraits sharp, but at very high ISOs (over 400) will add noise that may make the photo unusable.

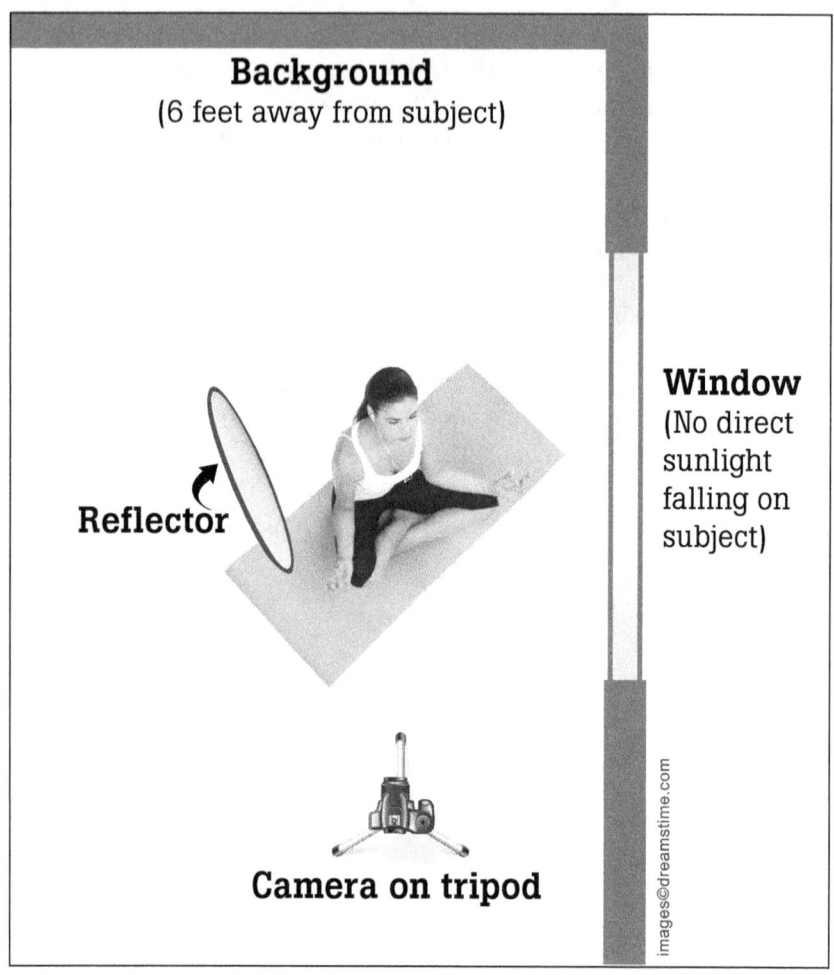

Windowlight Portrait Setup

Shutter Speed

While aperture determines how much light is allowed through the lens, shutter speed determines how long the light is allowed to enter. Camera use a 'shutter curtain' which slides across the camera and lets light strike the camera's chip for a precisely measured amount of time.

Just like the whole f/stops we use with our apertures, there is a range of **whole stops for shutter speed**. They are:

1 second | 1/2 second | 1/4 second | 1/8 second

1/15 second | 1/30 second | 1/60 second | 1/125 second

1/250 second | 1/500 second | 1/1000 second

This range can be extended both ways depending on your camera. The next whole stop would be twice or half the previous time. For example:

The next whole stop more exposure than 1 second would be 2 seconds; the next whole stop less exposure then 1/1000 second would be 1/2000 second.

These are all interchangeable with whole apertures.

For example, if you start with an exposure of 1/500 second at f/8 and want to change to f/16, you would just change the shutter speed to give two stops more light because the change from f/8 to f/16 cuts down on your exposure by two stops. You shutter speed then would be 1/125 second, the speed two whole stops before 1/500 second.

When we change exposures by whole f/stop of both shutter speed and aperture to obtain the same relative exposure, we are using the law of reciprocity. This law states the if you go up a number of whole apertures, and down an equal number of shutter speeds (or visa versa) your image will have the same density.

Controlling Motion

The shutter speed you select must work with the aperture you are using in order to create an exposure with good detail in both the highlights and shadows.

In addition to balancing the exposure equation, shutter speed determines how subject motion is rendered, and how much camera shake affects your image.

A higher shutter speed (smaller fraction) freezes action and makes camera shake less noticeable. Slower speeds can be used when a blur is desired. For example, you may want to allow flowing water to blur to create a 'cotton candy' appearance in its highlights. A slow shutter speed can be used in conjunction with a camera movement that matches the speed of a moving subject to create 'panned action' photos.

Controlled motion. A higher shutter speed freezes action.

Using a slower shutter speed (around 1/30 to 1/8 second) you pan the camera sideways at the same speed a moving subject is passing you. The subject will remain relatively focused while the background will blur, giving the sense of the subject motion in your photo.

ISO

ISO (short for International Standards Organization, the body that determines how to label camera chip sensitivity among other things) is a relative measure of how much light must hit your camera's chip to create a well exposed photograph. ISOs are arrayed in whole stops, just like aperture and shutter speed. The **whole ISOs** are:

50 100 200 400 800 1600 3200 6400 12800

Because of the way the ISO speeds are arranged, you can use them interchangeable to help achieve a desired exposure. For example, if you

are shooting sports in low light and have your camera set at:

ISO 100, f/5.6 at 1/30 second

you will almost certainly have camera shake. Using the ISO as a creative control you could change it to 800 then change your shutter speed by 3 stops and get this exposure:

ISO 800, f/5.6 at 1/250 second

By changing from 1/30 second to 1/250 second you would be much more likely to have a sharp photo.

Using the three controls together you can usually create an exposure that will render the scene with the emphasis you wish to create in the photograph. If you can't find a combination that works for your specific image situation you may have to add light to the scene by using a photo flash or other added light source.

Composition

When we compose something, we are arranging its parts so that they make sense to our brain in some way. In order to communicate through photography we must organize the visual elements in the photo to emphasize parts of the image and make other parts less important. We do this using a variety of photographic techniques and equipment.

People raised in industrialized countries have nearly all learned to recognize a common set of symbols and to view photographs in similar ways. Some of this is learned, but most cognitive scientists currently believe that there are certain aspects of perception that are hardwired into our genetic structure. For example, we don't need to explain the ideas of contrast to someone who views our photographs. If an image has too much or too little contrast, most viewers 'feel' it before it is pointed out. At the very least most people will prefer an image with better contrast by direct comparison.

You can become a better photographer, and a better communicator, if you understand some basic rules of composition and some of the rules that guide our interpretation of images.

Balanced, but not too balanced

Balance is important in every aspect of our lives. A balanced diet is a diet that offers a variety of foods keeps you healthy. Even if you really love eating chocolate cake you must have other foods that provide the vitamins, minerals, proteins, amino acids and other nutrients to keep you alive. You may love sports or video games but again, if that's all you do your life lacks balance and you won't be very well rounded or interesting.

Artists must consider balance as well. Balance in photographic terms means that the arrangement of line, shape, texture and color in the two-dimensional visual field of the photograph are arranged and distributed to provide the viewer with an experience that resonates with parts of the brain that decode our visual experience.

There are two main approaches to visual balance. The first is symmetrical balance. This means that for every object on one side of the frame there is an object of equal visual impact on the other side of the frame. This is generally too static and does not result in exciting photographs.

A more interesting approach is to create dynamic symmetry. Dynamic comes from the greek word *dynamikos* meaning powerful. In modern language it refers to force or energy. Dynamic symmetry therefore is a way of arranging the elements of your photograph so that they are in balance, but also present force or motion. There are several main design approaches that create this style of design. (See page 112).

Creating Composition

Photographs are powerful communication devices. To make photographs that are truly successful at communicating, the photographer needs to use composition to arrange the subject and objects in the picture to effectively guide the viewer through the picture.

The major tools that photographers use to compose their images are the same as those used in other visual artistic endeavors. Composition is defined in several ways. One of the most useful is to describe overall principles that identify relationships within pictures, and the elements that are used as building blocks.

Three major principles are active in the composition of photographs: Balance, Perspective and Juxtaposition. These principles are interrelated and do not function independently of each other.

Balance

Balance is the way that parts of a photograph work together to provide stability. This effect may create equilibrium or dis-equilibrium. A frame is the rectangle of the viewfinder in a camera or the edges of a picture. Balance allows the viewer to move through the image and see and use the information within the picture. Motion and weight are the most important concepts involved in balance. In still photographs, both are only implied by visual elements.

Geometric Center vs. Visual Center

The human eye tends to see the center of a frame slightly above the geometric center or physical center. It is the visual center that determines the activity in the picture.

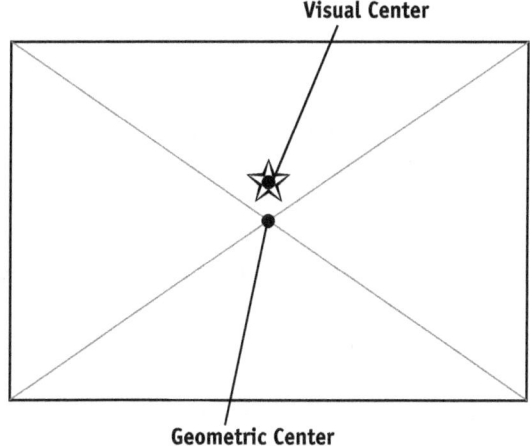

The Visual Center

Just above the exact geometric center of your image area there is a spot called the 'visual center.' This is the place where people will naturally look first for the main subject of your photo. You can use that to make your photo accessible or you can place your main subject somewhere else to create more tension in your design.

Motion vs. Static Balance

Motion in a photograph is the effect of the elements within the picture that causes the eye to move. A frame has two non-motion-producing places: 1) the visual center and, 2) the bottom edge of the frame.

If the central subject or major structural elements are at either of these locations, the picture will tend to be static and lack apparent motion. This is neither good nor bad, just a choice. Static images tend to be quiet because they have little induced motion and are in equilibrium.

Dynamic vs. Symmetrical: Visually, pictorial elements appear to move toward the visual center and the edges of the frame. The apparent motion increases as an element gets closer to the center or an edge until it is no longer visually separated from the center or edge. In the frame, certain areas create greater amounts of induced motion. Areas near but not touching the edges, the visual center and areas above the visual center tend to induce more motion than those below the center or those midway between the center and edges. In Western culture, because of the direction of reading, the area producing the most motion is slightly above the visual center in the right portion of the frame.

When elements of a picture are arranged to induce the feeling of counteracting motion, or motion in two or more directions simultaneously, then the image stays in balance. Photographs that use this method for balance are said to have dynamic balance.

Symmetrical balance means that the frame has about the same size, number and weight of elements on either side of the vertical centerline. Visual forces on each side counterbalance each other to create equilibrium. A common way to use balance in a photograph is to apply the Rule of Thirds. This places the subjects on intersections of the lines dividing the frame into three equal parts vertically and horizontally. If one intersection is used, the image will produce a more dynamic balance than is found in a symmetrical arrangement.

Most often, balance is thought of as the equalizing of weight, Visually, this is a good way to look at this principle, but in reality, visual weight is a much more complicated issue than physical measurement.

Visual Weight: Variables that influence a viewer's estimation of an object's visual weight are:
- Size
- Brightness
- Sharpness
- Importance (or Recognizability)
- Perceived Depth
- Position

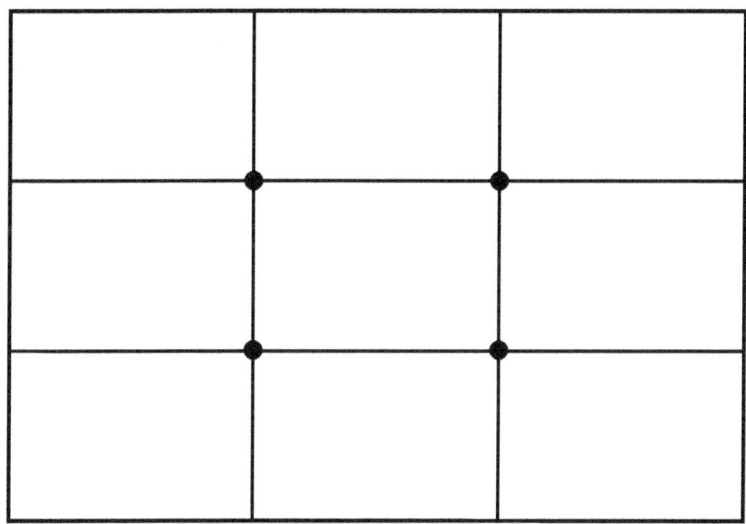

Rule of Thirds

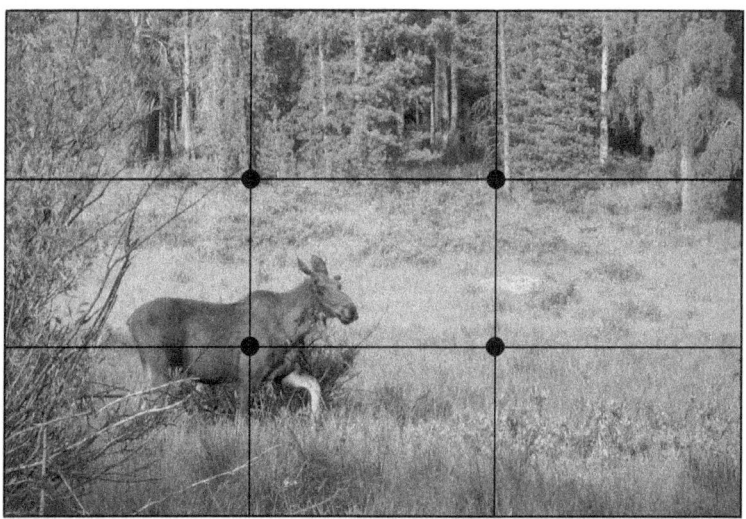

Dynamic Symmetries

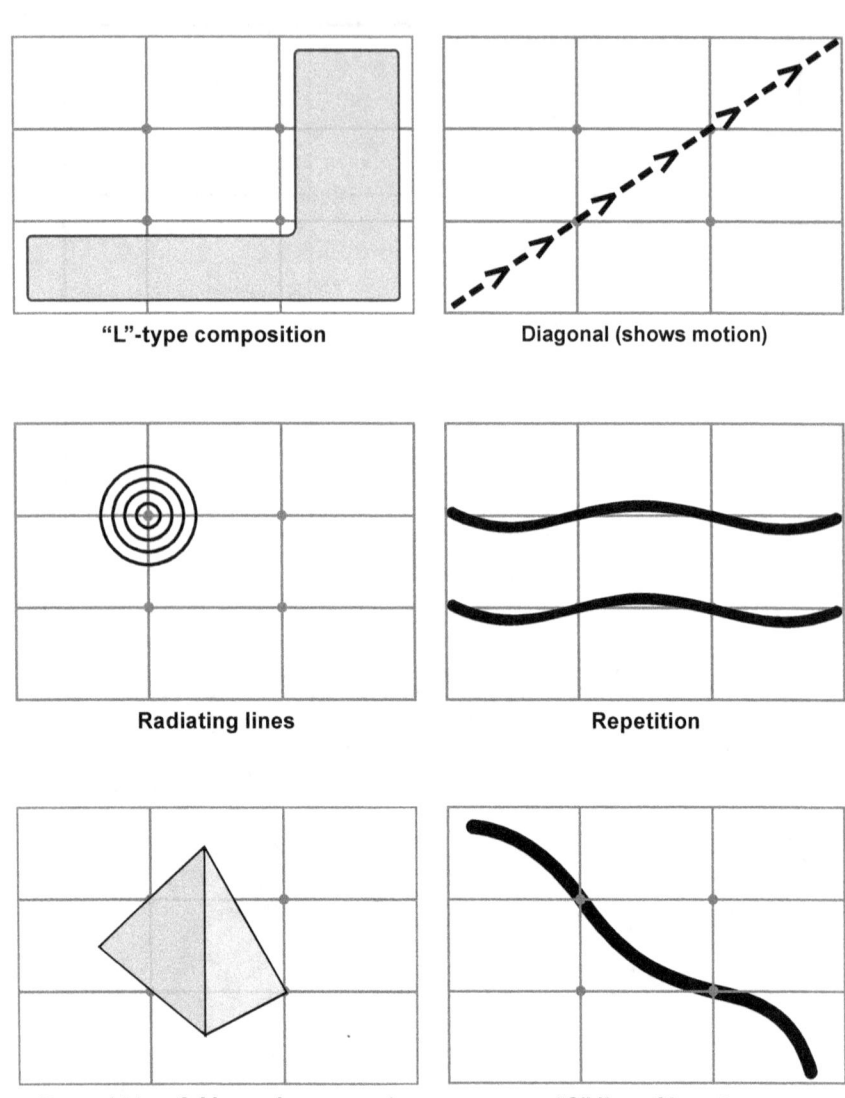

"L"-type composition

Diagonal composition

Radiating lines

Repetition

Learn by Doing • Photography

A pyramid portrait

"S" line of beauty

Gaze motion studies

Perceptual scientists attach sensors to test subject's eyes that record how they react to a new two dimensional image, such as a photograph.

By compiling data from thousands of such tests, they produced the 'gaze motion study' diagram which lets you track where your viewer's eyes are most likely to look for information about the subject of your photo.

Gaze Motion Study

Color

Everyone perceives color somewhat differently. There are visual defects such as color blindness that cause people to see color in vastly different ways. The important thing to remember about color is that with careful attention to detail, it can be reproduced so that you get the colors you expect when you are making prints, websites or published materials.

Color is created at the atomic level based on the energy that atoms emit. Our eyes have 'cones' which react to three different colors by emitting a substance called 'visual purple' which notifies the visual cortex that a tiny part of the image you are seeing contained some red, green or blue. Because our eyes are sensitive to these three colors, they form the basis for all digital imaging.

Cameras, computer monitors, television sets and digital projectors all create color by combining different amounts of red, green and blue. We

generally abbreviate this as RGB. By combining red, green and blue in different amounts and strengths we can create all of the color seen by the human eye.

Whenever there is a part of an image that has equal amounts of red, green and blue we say that this is a neutral tone. A neutral is any gray, black or white that has (nearly) equal amounts of the three primary colors. This is the reason that we use gray cards for color balancing. They provide a reference which we know is neutral. We can use to it calibrate the system for the specific lighting situation in which we made our photographs.

RGB – CMY

The additive primaries, red, green and blue in equal amounts create white light. Each of these additive primaries can be added to another additive primary to form a subtractive primary. When working with color correction we look at the additive and subtractive primaries as opposites. For example, cyan is composed of blue and green. Since it does not contain any red it is essentially the opposite of red. If we have an image that is too red, we correct this by taking out red, or adding cyan.

The other pairs of opposite colors are green and magenta (magenta is red plus blue) and blue and yellow (yellow is red plus green).

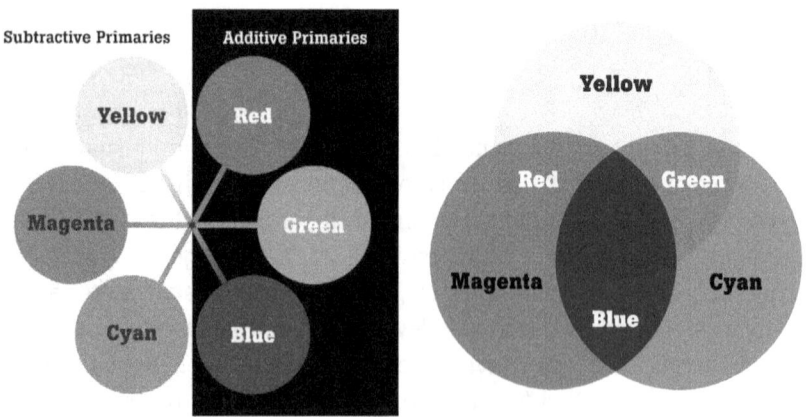

It is important to remember these color pairings because whenever you have to correct a color in your image you need to know that if you correct too much, you will cause the photo to have too much of the opposite color.

Something else to keep in mind is that when you correct color in a photograph, your brain has to adjust to the correction. When you first make an adjustment, the image will tend to look like it has a color shift that is opposite the one you tried to correct. This happens because your eyes are constantly color balancing in an attempt to create neutral colors for you. Even if the color balance of a photo is incorrect, your brain has adjusted to it so that when you change the colors to what they should actually be, your brain has to redo its neutral balance. Until it does, it will be telling you that the photo has a shift. It is best to make the correction then close the image and wait for your brain to reset, then open the image and check the color again. Sometimes it helps to look away at a white wall or gray card causing your brain to create a neutral balance.

Color temperature

Kelvin Temperature: Describing the Color of Light. In 1848, William Thomson (later granted the title Lord Kelvin) created a new temperature scale to account for the recent discovery of absolute zero, the temperature at which everything freezes completely and nothing moves. As it turned out, this magic temperature was -273° Celsius. Lord Kelvin created his scale so that -273° Celsius was the zero point. Therefore, in the Kelvin system water freezes at 273°K and water boils at 373°K. Soon after its formulation, the Kelvin scale became the standard used by physicists for temperature notation.

Physicists do much of the basic research relating to the way the world operates. When they wanted to find a scale for the measurement of color temperature it was natural for them to choose the Kelvin scale.

As with all things in science, it was deemed important for all scientists to be able to describe the color or light in the same way. Blue might be described as "navy" or "sky blue" or any number of other names, none of which has any objective meaning.

In order to create a standard way to describe the colors of visible light, scientists heated a special object (called a black body radiator) and measured its color at each temperature. These colors, or "spectra", became the standard for comparison.

In photography, Kelvin temperature is most often encountered when discussing the color balance of light. Average daylight is 5500°K (sunlight) and light from normal light bulbs is about 3400°K.

White balancing your camera is a way to set the color it records for the correct Kelvin temperature. While most cameras offer an automatic setting, it is more accurate to use one of the specific settings for daylight,

light bulbs, flash, fluorescent or other settings on your camera. Still better is the use of a gray reference card which you can photograph and use as a reference for a custom white balance setting. (See your camera manual to learn how to set a custom white balance.) If your camera won't set a custom white balance you can photograph your reference card then use it to color balance your images in Camera Raw, Photoshop or Lightroom.

Photoshop color

Photoshop defines and stores color using '1s' and '0s' (ones and zeros) grouped into sets of eight numbers. In the binary number system (a computer numbering system where you can only count from 0 to 1) you can count up to 256 (base ten) using 8 digits.

We use the numbers 0 to 255 to indicate how much of a specific color is present in each pixel in a Photoshop image. The values of red, green and blue can each be recorded in values from 0 to 255 giving us 256 shades for each of them. Since the colors are added together to make other colors, we can multiply the number of possible colors for each channel to get the number of colors possible with all three channels (256 x 256 x 256). That means we can produce over 16 million colors in the 8 bit (sometimes called 24-bit) palette in Photoshop.

Just to confuse things, Photoshop now works with 16-bit color which means that each RGB channel can hold up to around 16,000 shades of its color. This gives an overall palette of around 281 trillion colors.

Since the human eye can discriminate only about 8 or 9 million colors by direct comparison, why do we need all this extra color capacity? The answer is visual noise. We want to start out with as much information as possible because as we edit, store, transmit and print photographs we lose information. The more we start out with, the more we can afford to lose and still maintain a good quality final product.

Flesh tones

Correcting flesh tones is critical in creating photographs for most of us because nearly everyone photographs people. The correct rendition of skin tone in these portraits has a large impact on the success of the photos. Even for the very skilled at color correction, flesh tones can present a problem. Making a minor error in the color of skin can leave your portrait subject looking jaundiced (too yellow), nauseated (too green) or dead (too blue). Add to this the fact that many of our monitors are not perfectly

profiled for color and you have a really sticky situation.

In order to make flesh tone color correction manageable, you must first understand that there is a correct color for skin tone and it can be created by manipulating the colors in Photoshop without any need to be able to judge the perfect balance by eye. Using the technique outlined here, we have balanced skin tones on monitors that don't accurately display color. In one instance, the monitor had a burned out channel and everything displayed as magenta.

The secret is in the balance between the yellow and magenta in skin color. You simply need to balance these two colors and nearly all skin tone will be rendered correctly. For average Caucasian skin the yellow channel should be between 2 and 6 points higher then the magenta. For oriental and Hispanic skin the yellow should be 4 to 10 points higher. African skin tones generally follow the same model with the yellow being 3 to 10 points higher then the magenta. With very dark skin tones you will find that the cyan channel will be higher (up to about 30 points) but for nearly all skin tone the basic yellow to magenta balance is a more accurate way to balance than attempting to do it by eye.

Another benefit to this form of color balancing is that it creates files that will print with warm, natural color on most systems from websites to properly-set home printers to offset printed publications.

What does Photoshop do?

Photoshop is the most widely used professional image editing program in the world. It was created in the late 1980s and has evolved through a new version at least every couple of years since that time. The current version is Photoshop CS6 which is also known as version 13. (If you hold the command key on a Macintosh computer and select "About Photoshop" from the "Photoshop" menu, you find that it's also called "White Rabbit Extended.")

Most of the editing done in Photoshop is what we refer to as 'pixel based' or 'raster based' editing. This means that a photograph is stored and edited in Photoshop as an array of individual dots (called "pixels," short for picture elements). Each piece of the image is a tiny dot that records information about the color and density of one very small part of the image. It takes millions of these tiny dots of information to create a photograph. When you change something about your photo, you are

simply making changes to the dots that form the image.

While Photoshop is mostly about dots, parts of the program also deal with lines and shapes. Adobe Illustrator is a program that facilitates drawing. It creates images by letting you describe shapes and lines using mathematical constructs called "vectors." Vectors let you describe objects by their outlines. Since vectors are described in the computer using the language of geometry, they can be made as large or small as you like without any loss of image quality.

In Photoshop, there are several tools that create vectors such as the shape tool and the type tool. It is important to remember as you begin using the program that these tools save information in your image differently than the information that describes your photographs. When you start creating, saving and printing images from Photoshop you will have to deal with the differences between bitmapped images and vectors (if you use the vector tools.)

In addition to the traditional image editing and creating modes, the designers of Photoshop have added tools for 3D object rendering and animation. These are specialized tools which we won't be exploring in this volume, but they will show up in the menus. You may want to experiment with these tools to see what they do. If you are going to be working in game design, the 3D tools are a simple introduction to the type of modeling used to create game characters and objects in the gaming environment. Please note, however, that game designers have much more powerful tools for actually creating objects to include in their environments.

Parts of the Photoshop desktop

Toolbox

The toolbox is separated into sections. Beginning from the top with the tools stacked side by side:

- The first 6 tools are for selecting parts of an image
- The next 8 tools are for correcting something about your photo
- The next 4 tools are for creating and manipulating vector graphic images (these are the ones that are made with math, not pixels)
- Next come two tools that work with 3D images
- The hand tool and magnifying glass are for positioning and scaling the view of your image

- The next section of tools work with the foreground and background colors
- At the bottom of the toolbox is a button that toggles the 'Quickmask' mode on and off

When you are looking at the toolbox you will see that some of the squares containing the tools have a black triangle in the lower right hand corner. This triangle means that there are other tools sharing the same square. If you click and hold on that square, the nested tools will pop out so that you may select them.

If you click and hold on any tool you will see a menu pop out that will tell you the name of the tool and the keyboard shortcut for that tool. The toolbox shortcuts do not use a modifying key (such as control, option, alt, etc), you simply press the key indicated to select that tool.

Holding the 'Shift' key at the same time you type any keyboard shortcut will cycle through main tools that share any given square in the toolbox. For example, if you hold down 'Shift' and then type the 'M' key, you will cycle between the circular and rectangular marquee tools.

Menus

The menus along the top of the Photoshop screen contain commands that allow the photographer to make a variety of changes in the image currently being edited. These changes range from saving and changing the file type, size and format to adding corrective and artistic filters.

When you click your mouse over one of the menu selections a range of sub-menus will pop down. Look to the right of many of these sub-menus and you will find a series of letters and modifying keys that allow you to access them without using the pull-down menus. These are called 'key-board shortcuts' and learning them will make you much more efficient at using Photoshop. Working faster in Photoshop will make you more productive and a better employee.

The 'Window' menu contains a couple of important choices. First, it holds a list of other menus for all of the palettes that are available to you. If your palettes have been rearranged (more on that later) or turned off, you can always find them and reactivate them using the 'Window' menu.

You can also organize your copy of Photoshop the way you like it under Window > Workspace. Near the bottom of this menu is a selection called 'Save Workspace.' Organize the tools and palettes the way

you like them then save this layout and name it and you can always go back to your preferred workspace quickly and easily.

When a tool is selected, another layer of menus appears under the top layer. This set of menus is called the 'context sensitive menus.' This is because they change depending on what tool is active. For example, if you are using the 'crop' tool, the context sensitive menus let you adjust the width, height, resolution and other characteristics of the crop you are making from the image.

Palettes

The palettes in Photoshop are located along the right hand side of the screen by default. They generally give you information about the image on which you are currently working. You can see what layers are being used in the image, view the colors that make up any part of the image or create and alter masks that select parts of the image for different kinds of editing.

The palettes can be moved around the screen by simply clicking the top of them and dragging anywhere you like. You can also click the tabs on the image and add them together to create a set of palettes that are more tailored to the way you work.

In the upper right corner of each palette is an icon which opens a menu that allows you to change things about the way the palette works. These menus also add functionality by letting you do things such as add more brushes to the brush menu or more actions to the actions palette.

Most of the individual palettes also have a set of icons along the bottom that let you control things about the way the palette works or allows quick access to specific functions such as creating a new layer or mask.

You can make the palettes smaller by clicking and dragging on the left edge of the palette or by clicking on the double arrow at the top right hand corner of any palette. If you turn one off and need it back, you can always turn it back on in the 'Window' menu.

Canvas/image area

When you look at an image in Photoshop you will find that the image is surrounded by a gray border. The image is contained within a space in Photoshop known as the 'Canvas'. The canvas is the overall area available for you to work with your image. As you open an image, the Canvas is the same size as the Image. If you want to add anything to your image that fits around the actual image size, you must increase the Canvas size

so you have room to include your new material.
When adding this extra space there are a few considerations.

- Where should the original image be positioned in the newly created space?
- What color should Photoshop make the new background space?
- How much area do you want to add?

All these questions must be answered in the 'Canvas Size' dialog box.

Using Photoshop

What are image formats?

All digital files are stored as lists of '1s' and '0s.' The only thing computers can really do is make really fast work of basic mathematical operations on billions of digits.

In order to make sense of all these digits, computers format lists of numbers into digital "words" and they keep track of lists of these words using different types of tags and descriptors that indicate what the next set of digits should look like.

As photographs and other digital art became computerized, various companies found different approaches to storing these art files. The original files were called bitmaps on Windows-based computers and PICT files on the Macintosh.

The problem with these more primitive image files was that computer memory was limited and when we started making the files large enough to store images that could be printed with photographic quality (and in color) machines of the period simply could not handle that much data.

Because of this, a variety of people started working on ways to make image files smaller. Once such body was the Joint Photographic Experts Group which created a breakthrough in imaging by producing their JPEG format which made it possible to compress images to a very manageable size. While still in use, the JPEG format has a couple of problems. The biggest one is that it uses 'lossy' compression. In other words, every time you open and *save* a JPEG it loses quality.

Other formats have included TIFF (Tagged Image File Format) which is commonly used for photographs intended for print publication; PNG (an updated version of the JPEG format); the Photoshop Document or

PSD which is the default format for files created by the program; camera raw (a format that attempts to preserve the original information from the camera chip); and finally, DNG (Adobe's digital negative format.) There are many other file formats but those are the main types you will encounter in photography.

One of the most important functions of Photoshop is to convert images between all of these formats. Converting images is simply a matter of selecting the 'File' menu in Photoshop and then selecting 'Save As.' There is a list of file formats on the 'Save As' menu and by choosing the one to which you wish to convert your images you can create as many versions of your file as you need.

If you have a large number of images to convert to another file format you can use utilities in the Bridge application or Lightroom (for DNG format). The utility in the Bridge will let you convert images to several different formats at the same time.

What does P.P.I. mean?

There are a couple of abbreviations associated with image size in Photoshop (and digital imaging in general) the most common are P.P.I. and D.P.I. The first stands for Pixels Per Inch. This is not a measure of any actual size, it merely tells you how many discreet pieces your image is comprised of for each inch of its height or width. The actual size at which the image displays or prints depends on the P.P.I. of both the file and the device used to display the image.

If you have an image that is 72 P.P.I. and you print it on a device with 300 pixels of resolution, the image will print at about 1/4 the size you expect based on how many inches wide it is. You must match the image resolution to the display or printer resolution to get the image size you want to create.

The other main abbreviations is D.P.I. or Dots Per Inch. While many people use these two interchangeably, current usage dictates that P.P.I. refer to digital information such as camera, monitor or digital projector resolution while D.P.I. is applied mainly to printing devices. This can be more than a semantic difference. File sizes are described differently for different types of devices and keeping to proper usage of the terms can prevent misunderstandings.

Resizing and reformatting images

When creating original images with your camera you must always think first about the final use of the photo. If you know you are going to use the images for a website and nothing else, there is no reason to create files that are 15 or 20 megabytes. On the other hand, if you don't know exactly what the finished product will be, make the files as large as you can. You can always reduce file size in Photoshop, but it is difficult or impossible in many cases to enlarge them and get an image that can be used professionally.

Once you have made the image and archived it, you may need to create a variety of files for different uses. For example, you may need to make a large print which will require a big file size with high resolution. If you are placing the image in a website, you will probably need a much smaller file with less resolution and a different file format.

To change the size of an image in Photoshop, go to the 'Image' menu and select 'Image Size.' This will bring up a dialog box that allows you to change the height, width and resolution of your image. If you make a change in your file size, it will be shown at the top of the dialog next to the words 'Pixel Dimensions.' Make sure that after you make your changes that the first number is not larger than the second number and your image will be successfully resized.

Remember that you should always make a copy of your image before resizing or reformatting. Valuable image information can be lost if you make your image smaller and then save it, overwriting the original file.

Color correction

There are photographers who spend 20 hours or more working on their color profiles for every hour they spend behind the camera. Color correction can be a very daunting task. For purposes of this book we are going to look at the correcting files using a neutral gray reference card (or the more expensive but really great WarmCards™) and either the 'white balance tool' in Camera Raw or the gray balance dropper found in the 'curves' tool in Photoshop.

Balancing your images is rather simple and straightforward if you make sure to shoot at least one frame in each different lighting setup with your gray or warm reference card. Just get your shot all ready to go then hold the reference card in the frame and shoot one photo. Then, with the card out of frame continue shooting as you normally would. The card need not be right next to your subject, it just needs to be in the

same light. So, make sure that if you are photographing a landscape in direct sunlight, your reference card is in the same light. That's all there is to it.

When you get back to the computer to process your images you can select them in groups and color balance a whole group at the same time. Make sure the reference card image is showing in the preview window in camera raw, then select all of the other images shot in the same light and touch the gray card with the 'white balance tool.' This will correct every image for color and density at the same time.

Curves correction

Correcting color is always easier if you have a reference on which to base your color rendering. Anything pure black, white or gray will suffice so long as it has some surface detail. Pure, featureless white and dead black are not good choices because they tend to skew the image toward being too light or too dark. The best choice for most images is to include a middle gray reference in your original photo and use it to establish a color balance for all images shot at the same time (and same lighting).

You also need to tell Photoshop what you consider to be a well-defined black, gray and white. Do this by opening the 'Curves' dialog (type command-M on the Macintosh or control-M in Windows). In the Curves window are three small pictograms of droppers. One has a black tip (for shadows); one has a gray tip (for midtones); and the last one has a white tip (for highlights).

By double clicking each dropper you can enter values that tell Photoshop what you think are the best choices for your neutral highlight, midtone and shadow values.

In the dropper windows there are five sets of numbers. You enter values for any set of numbers. We will use the CMYK values because this set offers one more value making it possible to be a little more accurate with the tones you enter. Keep in mind, though, that you could enter neutral values using any of the five number sets.

Starting with the black-tipped dropper **(shadow values)** enter the following numbers:

C=72 M=63 Y=63 K=90

[If you are entering values for photos that will only be used on television or the Web, you should make the 'K' value 100. This is because print media can't handle pure black but monitors can.]

Next we enter values for the **midtones:**

C = 50 M = 40 Y = 40 K = 10

Finally enter the **highlight values:**

C = 5 M = 3 Y = 3 K = 1

[You always want to have some level of detail in your highlights. Leaving the default settings of all '0's means your lightest highlights will print as paper-based white. That is never a good idea]

One final note: You may notice that all of the cyan values are a little higher than the yellow and magenta. This is to offset a trend that has been observed for American printing to be a little too red. This is obviously subject to changes in the trends of color reproductions. Also, these are beginning numbers, and as you work more in Photoshop and color reproduction in general, you will probably establish your own values for these numbers.

Sharpening

It is important to remember that Photoshop can't actually make an image sharper. Once you make the exposure the actual sharpness of the photo is locked in by the sharpness of your lens, the alignment of your lens and camera body and other factors.

What Photoshop can do is enhance the contrast in the boundaries between dark and light areas in your photo that creates the appearance of increased sharpness. There are several selections in the sharpening menu (located within the filter menu), we are going to discuss three ways to approach sharpening. Each photographer eventually finds the method that works best with their style of photography and work flow.

Unsharp masking

Of all the basic sharpening tools, unsharp masking offers the easiest interface with the greatest control. When you select unsharp masking you are offered a dialog box with three adjustments. They are: Amount, Radius and Threshold.

What each of these mean is beyond the scope of this text. When you start out using this tool, enter the following values into each of the three boxes:

Amount = 85

Radius = 1.4

Threshold = 4

If you want to sharpen an image more or less, adjust the 'Amount' to between 0 and 125. Don't change the other settings until you understand what they do.

Unsharp masking is a good basic sharpening method and it works quickly and easily. If you find that it is not good enough for the image with which you are working, try the next method, 'High Pass Filter Sharpening.'

Digital Asset Management

Whether you are an aspiring professional photographer or simply want to take better family photos, if you shoot with a digital camera, you will end up with a lot of images. Unless you love spending hours of your time in the sometimes futile search for the photo you want to print, upload or email, you need to start from the beginning with a systematic way to keep track of all of those images. Losing a photo of your sibling, child or grandchild can be heartbreaking; losing a photo of a celebrity, event or travel destination can cost you big money in lost licensing revenue.

The approach many top photographers use is called digital asset management (DAM). There are software packages made to make DAM easier and faster, but the bottom line is, you are the one who has to create the structure and stick to it or your images will end up lost in the digital void.

In this chapter we will take you step by step through the basics of DAM. The tricky part is that you have to view this as something worth your time and take is seriously or it won't work for you. It is easy to come home from a shoot, crack open cold, tasty beverage and put your feet up to watch some television. You should get in the habit of managing your images as soon as you get back to your computer. Details such as names, places and times leave your mind quickly and it is much more difficult to track them down later than to just enter all the information while it is fresh on your mind. Also, if you immediately download your photos you won't take a chance of accidentally erasing them before you get them downloaded.

Downloading your images

During the shoot you should make it a practice to have a pad and pencil or a small voice recorder. A GPS photo tracking device is also a good idea if you are shooting away from home. Having a device to keep track of where you made your images means one less thing you have to think about while you are shooting. Use the pad to record names, places and any other details you might want to know later.

Backup first!

You always want to make sure you create a backup of your photo files as soon as they come from the camera. You need to preserve the camera original files. One of the best ways to accomplish this is the burn them to CDs or DVDs. You can't save over a file on a DVD so it is a great way to make sure you original files are always available. Once you have burned the disk, place it in some kind of archival storage and forget about it unless you get into a situation where you need to access your original.

If you don't have a DVD burner or don't want to create a lot of disks, use a large disk drive to hold your backup camera files but don't use the same drive for day to day access. A drive that holds about 1 terabyte is a good choice for these backups.

Converting to DNG format

Why do we convert to DNG? When we start looking at DAM, though, we have to think in terms of long term storage and accessibility of the image files. There are almost as many raw formats as there are cameras. As the years go by, some of these raw formats may be dropped or revised leaving you with no way access your files. Adobe has created a new raw format called 'DNG' (which stands for Digital NeGative). The idea is that camera makers will adopt the standard and eventually all cameras will save DNG files so that all camera files will be compatible. That's the dream, we'll see if it happens. Hasselblad and Leica have already adopted the format. The best thing about DNG as a format is that Adobe has promised to support it for the next 100 years. This means your image files should be accessible long after you are gone.

At any rate, you are much more likely to be able to open, print and share you image files for years to come than is you keep them in a raw format that could be gone next year. I have already encountered problems downloading raw files from my Canon G10. Without a special piece of

Canon software, the files are can't be read by Photoshop or even iPhoto.

How do we convert? There are several ways to convert files to DNG format. Unfortunately, using Photoshop and Camera Raw the files must be converted one at a time. That can be very time consuming. Fortunately, Adobe offers a free converter on their website. Check www.adobe.com for the free download. It works on Intel-based Macintosh and also Windows computers.

The converter allows you to select a folder of raw images and convert all of them to DNG format at the same time. You can also batch process the image names. If you choose to, you can also embed the entire original raw file in the new DNG file, but this makes the files very large. If you have backed up your original raw files that is no reason to embed them at this point.

Structuring your file names

Being able to find your images later becomes a lot easier if you create a follow a consistent naming scheme. There are many approaches to naming, just make sure you remember what they mean. Will you understand what the name on your image means next year, 5 years from now or 25 years from now? If not, create a key and make sure you don't lose it.

There is some disagreement among DAM experts about whether to include descriptive words in your file names. For example using the brides name in wedding photos or the client name. Whatever you decide to do, be sure that your filenames are no more than 31 characters long and end with a dot extension such as .dng. That way they will be recognized by all current computer operating systems and should be portable into the foreseeable future.

As a good starting point, try creating names that begin with your last name, then add the date the image was created, add a serial number and finish up with the dot extension. The whole name would look like this:

harrop_040709_001.dng

When you are batch renaming imaging it can be tempting sometimes to reset the counter for every batch but you should not do that. By allowing the counter to run up to 9999 (The highest number on most systems.) you will end up with a lot more unique numbers, which will make for easier searching later on.

Append standard metadata tags

Once the files are converted and renamed it's time to add metadata. Metadata is information that is attached to each photo file. Some data is automatically generated by your camera. Other types can be added by the user.

You should create a file with all of your basic copyright and contact information that can be added to every image you shoot. Another file can be created with notes and other information that can be added to images from each specific shoot.

Rate your images

Adobe Bridge permits rating of images using from 0 to 5 stars. Use this star rating system to create a way to sort your first edits, second edits, etc. When you are evaluating your shoot, get in the habit of putting 5 stars on your best images. Later, when you want to find photos for a portfolio or family album, you will already have done the sometimes tedious work of figuring out which ones are best.

Keep in mind, though, that sometimes when you look through a set of images you see different qualities. You may just overlook a great image. From time to time go back through the images you have saved with less than 5 stars and take another look. You may find a diamond in the rough hidden among all those files.

Storage and backup

How many copies?

Digital files can be corrupted, accidentally erased, created with software that become obsolete or simply lost. For this reason, it is prudent to keep more than one copy of any important photograph. The problem is deciding which photos are important. Many photographers quickly erase images they don't see an immediate need for.

Time Magazine photographer Dirck Halstead learned the archiving lesson very directly. Halstead was one of the photographers assigned on a rotating basis to cover the Clinton White House. When the Monica Lewinski story broke he had a feeling that he had seen here before but didn't know where of when. He hired a researcher to go through his photo archives and they found a photo of Lewinski standing right in front of the President. Both Halstead's magazine and his agent had gone

through the photos but they didn't find the image. Had Halstead deleted his outtakes, we would have lost a historically important photograph.

The real point is that in many cases, you won't know whether or not a photo is really important until months or even years later. The best option is to keep everything you shoot unless a frame is an obvious exposure error, blur or another shot of your feet as you try to figure out how something works on your camera.

So, if you are going to keep your photos and keep them safe, you need to have at least 3 copies. Burn a copy to a DVD or CD as soon as you download. Since DVD-Rs and CD-Rs can't be erased of rewritten, these copies are very clean copies of your original files.

Keep a second copy in your main photo archive and the third on some sort of back-up media such as an inexpensive removable drive (We use a nifty USB2 unit from Thinkgeek.com.) or even an online archive such as Flickr or one of the other similar services. A professional account on Flickr allow unlimited storage of reproduction size image files for only $25 per year. Keep in mind though, that there have been concerns about people using your images when they are in the online environment.

Setting up your file structure

Keeping in mind that your file structure must make sense mainly to you, you should also plan for the eventuality that someone else may be assisting you some day, or that you may hand over your archives at some point to a third part such as a stock agency.

The file architecture we recommend is called 'top down' organization. A top down system mean that you are organizing everything starting from top level folders and making sub-folders inside them that contain broad categories.

For example, your system might contain main directory folders called family photos, client work, personal work, school work and so on. Keep the number as small as practically possible. If your main pursuit is nature photography create a folder for that.

Inside those folders create other folders that break down in to smaller categories. For example in your client folder you might have sub-folders such as 'magazines,' 'portraits,' travel,' and so on.

Within each of the sub folders make a folder for each shoot and name it according to you naming scheme. The idea of all of this is to create a structure that works even if your search utilities don't find the image you are seeking. You want to be able to 'drill down' to a general area of your

file system without have to rely on outside software.

Directory naming

Naming your directories (or folders) is a matter of personal preference but here are some guidelines:
- Be consistent—Don't use frivolous or funny names because they may not mean anything to you 10 years from now. Use names that relate to the photos or at least indicate information such as the date or a sequence number.
- Don't use special characters (such as the # symbol or even a "/" because they may cause problems on some systems.
- If you use sequential numbers, dates or some other abstract name, keep a log somewhere that tells you what is in the directory. It is easy to do with any database or spreadsheet program.

DVD and CD naming

Use names for your disks that follow a different scheme than your directory names. In other words, don't use the same names. If you end up with a whole list of disks and directories that have the same name, searching will be very frustrating. You might consider simply putting DVD or CD at the beginning of every disk name so that it is obvious what you are looking at in a search.

Your disk name could be something like: **DVD_Harrop_070409**

This tells you that this DVD contains your authors images and they were taken on July 4, 2009. May times just having a little information can help with quick visual scanning to find a file with using your DAM.

Tracking derivative files

One of the main difficulties in dealing with a large group of images is being able to find the right version of a given image. You may create a black-and-white, line drawing, filtered or even simply color corrected file which has about the same name as your original image file. We refer to all of these files as 'derivatives.'

When creating a new version of an image file it is a good idea to save this derivative version in an entirely different place than the original so that you know at a glance what version of the file you are opening or copying.

Name the derivative folders with the same title as the file in which the original is stored but add the word 'copy' or 'altered' or something else

that tells you that these are not the cleanest versions of the files.

Logging your shoot in

When you get back from a shoot it is a good idea to make some notes about the who, when, where, why and how of the shoot. Who was the client? What is their phone number? Do you need to do any follow up.

It is easy to do this is a database program. There are many cross platform databases in which you can create a simply file with a way to access information.

Since the date is recorded in the metadata for nearly every camera, it is a good reference for all of this information. Most operation systems these days come with some kind of calendar installed. You can enter the date and contact information for the shoot in the calendar and it will be available at any time in the future. This is a really simple way to keep track of all information for a given photo shoot.

About the author

Thomas Harrop holds both bachelor of art's and a master's of science degrees from the prestigious Brooks Institute of Photography. He has worked as a photographer for NASA's Edwards Air Force Base facility and his photos have appeared in many national publications including *USA Today*, *PC Laptop*, *Snowmobiler*, *VISIO*, *Hot Boats* and many, many others.

Thousands of photographers have improved their craft by reading magazines such as *Petersen's Photographic*, *Camera & Darkroom* and *Outdoor Photographer*, all of which Harrop has served as Editorial Director or Managing Editor.

In addition, Harrop has been listed in *Who's Who in Media and Communications* and *Who's Who in the West*. He has been accepted into the Royal Photographic Society of Great Britain (the oldest photographic society in the world) and American Mensa.

For the past 14 years, Harrop has taught photography at the college level and he is currently a member of the Society of Photographic Education and the Professional Photographers of America.

More from Whitefish Editions
Also available as Kindle ebooks

The Complete Digital Photography Primer

The Complete HDR Zone System Primer

Web 2.0 for Your Business

Coming Soon: Learn By Doing – Citizen Journalism

Available Fall 2013

www.lulu.com/spotlight/HARROPmedia

www.ingramcontent.com/pod-product-compliance
Lightning Source LLC
Chambersburg PA
CBHW060859170526
45158CB00001B/422